This edition published in 2018

Search Press Limited
Wellwood, North Farm Road,
Tunbridge Wells, Kent TN2 3DR

First published by Arc Publishing and Print in 2014

Photographs, illustrations and text copyright
© Stephen Coates, 2014

Photograph on page 24 of Prolene series 101 round brushes courtesy of Pro Arte www.proarte.co.uk

All rights reserved. No part of this book, text, photographs or illustrations may be reproduced or transmitted in any form or by any means by print, photoprint, microfilm, microfiche, photocopier, internet or in any way known or as yet unknown, or stored in a retrieval system, without written permission obtained beforehand from Search Press.

ISBN: 978-1-78221-561-5

The Publishers and author can accept no responsibility for any consequences arising from the information, advice or instructions given in this publication.

Suppliers
If you have difficulty in obtaining any of the materials and equipment mentioned in this book, then please visit the Search Press website for details of suppliers: www.searchpress.com

You are invited to visit the author's website:
www.coatesart.co.uk

Printed in China through Asia Pacific Offset

Acknowledgements

Special thanks are extended to the following people:

To my students past and present, without whom I would not have had the opportunity to practise my teaching methods. Their enthusiasm and encouragement has played a vital part in the maintenance of my self belief.

To fellow authors Frank Clarke, Ron Ranson and Ray Campbell Smith who have unknowingly inspired me through the teachings and paintings in their own books.

To Chris Keeling at Arc Publishing for help, guidance and support during the publication of the first edition of this title in 2014.

To Emily and Katie in the editorial department at Search Press. Their enthusiasm, commitment and professionalism is to be admired and much appreciated.

To my parents, Brian and Dorothy, for their limitless belief and support – both emotionally and financially!

To my grown-up kids, Matthew and Katie, for believing in Dad!

And to Lesley, my reason for doing what I do!

The Watercolour Enigma

A COMPLETE PAINTING COURSE
REVEALING THE SECRETS AND SCIENCE
OF WATERCOLOUR

STEPHEN COATES

SEARCH PRESS

Contents

Introduction ... 6

PART 1: THE SCIENCE OF THE MEDIUM ... 8

PART 2: WHAT YOU WILL NEED ... 21

PART 3: INITIAL EXERCISES & PAINTINGS ... 28

 Feeling the fluidity ... 30
 Exercise One

 Learning to blend in squares and circles ... 33
 Exercise Two

 'Pebbles on the Sand' ... 39
 Exercise Three

 'Across the Bay' ... 51
 Exercise Four

 'Red Sail Reflections' ... 59
 Exercise Five

PART 4: UNDERSTANDING COLOUR & MIXING ... 69

PART 5: THE FINAL TWO PAINTINGS ... 77

 'Lake in the Snow' ... 79
 Exercise Six

 'Peak District Walk' ... 96
 Exercise Seven

PART 6: CONCLUSION & GALLERY ... 112

Index ... 128

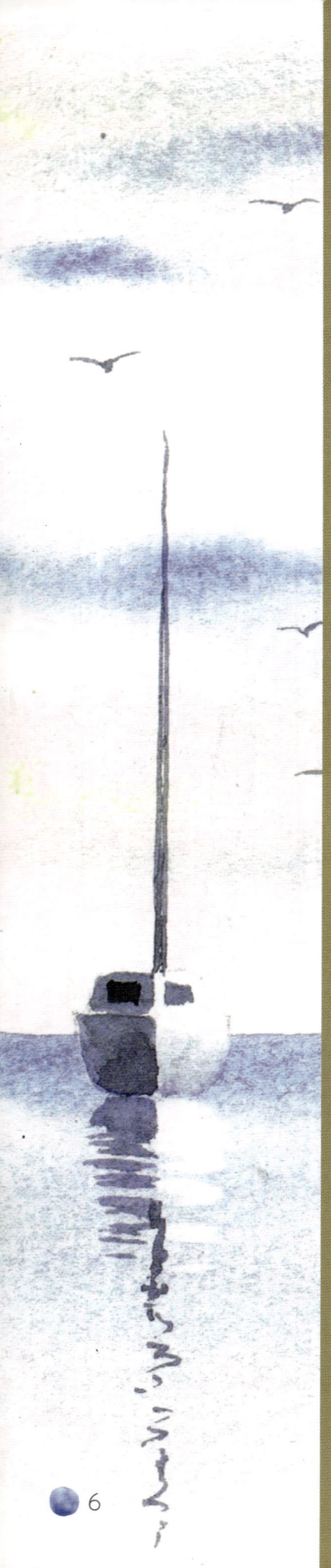

Introduction

Welcome to *The Watercolour Enigma: A Complete Painting Course Revealing the Secrets and Science of Watercolour*. You may have selected this book in a shop, bought it online or even at a car boot sale! It would be lovely to think that it has been recommended to you by a friend, a book shop or a teacher. Whatever the circumstances, thank you for buying it. I hope sincerely that you find the contents stimulating, exciting and inspirational, whether you are a complete beginner or seeking to improve your skills. The use of watercolours in this book is likely to be very different from your expectations, even if you already use the medium. With perseverance and practice, this course will bring you to a better understanding of the medium, and help you get the results you are looking for.

I chose to specialise in watercolours many years ago. Like most people wanting to learn, I bought books, videos and DVDs. I did not progress as quickly as I would have hoped and found the whole process a bit frustrating. My own determination to succeed led to countless hours of trial, error and practice. Along the way I discarded far more work than I kept. A lot of it was ripped up and thrown angrily at the bin! Eventually, it all started to click into place. I realised I had learned very little from books; instead my proficiency had come from learning by mistakes and doggedly sticking at it for all those years.

Most successful artists will be in possession of two key skill areas. Firstly, they will be visionary and imaginative with a good understanding of composition in order to lay out their ideas effectively. Secondly, they must possess the technical skills in their chosen medium. In my view the two skills are quite different. Vision and creativity tend to be more inherent, but technical ability is all about understanding, development and practice. Most artists would agree that no matter what subject they are working on, physical performance on the paper or canvas is the most important part. The better your understanding of the medium and the more you practice, the more chance you have of producing a successful work of art!

I do not want to be rude about other books on the market; after all, the other authors might not like this one too much! However they do all seem to fall into a similar format. Most of the books I have read contain paintings by the artist for you to copy. The instructions provided rarely give sufficient technical information about what the artist actually did to produce the end result. When you are learning to use watercolours, it is unlikely you will be equipped with the technical ability to recreate the work of an expert. It is my view that you are more likely to give up as a result of this potential frustration.

I have been running watercolour courses in my teaching studio for many years. The aim of the course is to take away the years of frustration that I went through and bring students to a better understanding of the watercolour medium in a much shorter time. The motive behind the writing and compilation of this book is not to show you how good I am, but to help **you** succeed. It is for that reason that I have selected subjects that I believe are realistic and achievable by you as you learn. I have also provided dozens of progressive photographs and detailed written instructions. I hope all this will give you a real sense of control and feel as you develop your skills.

This book will take you through a series of lessons and exercises which I recommend you complete one at a time in the order they are presented. This is a course that has been designed for you to undertake in specific stages. I recommend you start at the beginning and resist the temptation to skip pages. You will learn about which materials and techniques to use as you go along. In particular, Exercises Two and Three (see pages 33–38 and 39–50) give detailed information and instructions about materials, tips and techniques that you will need throughout the book. They will not be repeated with the same degree of detail in the later exercises. I have attempted to bring the excitement and thrill of 'live' teaching into the pages of this book. I truly hope you enjoy the experience and achieve all your aspirations. I wish you the very best of luck.

1

The science of the medium

"The very thing that attracts people to want to paint with watercolours, is that the effects they produce cannot be achieved with any other medium."

The watercolour paradox

It is common for those new to painting to choose watercolours instead of other mediums like acrylics or oils. Firstly, it is undoubtedly cheaper to set up with watercolours. Secondly, using oils and acrylics involves large canvases, easels, huge brushes, palette knives and white spirit, things which are messy and expensive. Conversely, the notion of mixing a little water with paint from a pan or tube seems so clean and uncomplicated. Anyone can do that, I hear you say! Get a piece of paper, bowl of water, brush and a few colours and away you go. What could be easier?

I'm sorry to shatter your illusions but therein lies the paradox. Few beginners realise that the watercolour medium is regarded as the most difficult of them all, which is why many professional artists declare themselves 'out' when it comes to watercolours. They just find it too difficult. If you've been out and bought a set of watercolours, I'll wager you didn't realise you were in for years of frustration and self-annoyance!

Before continuing, I'd like to clear up any doubts you may now have as a result of the above revelation. The very thing that attracts people to want to paint with watercolours in the first place is that the effects they produce cannot be achieved with any other medium. In other words, the textures, colours and special effects that can be achieved using watercolours are unique to the medium. However, to make those things happen effectively, you cannot apply watercolour paint like the others. It just doesn't work. That single realisation is the most exciting part and when it starts to work for you there is no better reward. Rather than be discouraged, take heart: the truth is going to be revealed. So read on, and I hope you will find this as exciting as I did.

What is the problem, and why is it so difficult?

I wish I could give you a quick answer to those questions. The fact that I can't is why the medium is generally misused. Understanding the way watercolour behaves is vital to your success. For that reason I am going to help you get to grips with this by looking at some important facts about the watercolour medium.

The heading below has been deliberately printed with the word 'water' in capitals and the word 'colour' in lowercase. When you think of the word 'watercolour', try to picture it written this way. Water is by far the more influential component of the medium. The paint is delivered onto the paper using the water as a 'carrier'. Without water, the medium is useless. It is that fact alone that separates watercolour from any other medium.

WATERcolour

Let's have a look at what the dictionary says:

Oil paint A thick paint made with ground pigment and a drying oil such as linseed oil. Used chiefly by artists.

Acrylic paint A thick paint based on acrylic resin that can be thinned by water. Used as a medium by artists.

Watercolour paint Artist's paint made with natural, synthetic, mineral or organic pigments and a binder such as gum arabic, which are suspended in water and give a transparent colour when dried.

You will notice that the dictionary definitions of oils and acrylics above both include the word 'thick'. They can both be thinned with white spirit and water respectively, but once they are applied to the canvas or board they stay put. You can go back and manipulate the paint afterwards but it will always stay where you left it until you go back. Once they are dry, they are 'cured' and become a solid that cannot be removed or altered unless you chip it off or paint over it.

The most important part within the definition of watercolour paint is the word 'suspended'. Watercolour pigments are simply mixed with the water molecules until such time as the water dries up. The gum arabic binder helps the particles bind together and bond them to the paper. However, unlike oils and acrylics, the paint doesn't cure. The paint particles come to rest on the paper in the position they were in when the water dried up. However they will re-activate and part company with the paper if water is introduced again. In other words, watercolours are not permanent. This can be a good thing but is usually the cause of most frustration.

The science of the medium

I stated earlier that the water is more significant than the paint. The paint is simply 'carried' by the water and will therefore go wherever the water goes. The amount of water used and how it is directed by the brush will dictate the final destination of the paint. Getting control of the water is therefore a top priority. To learn how to control water, it is important to examine how it behaves. This may seem a bit like Delia Smith or Martha Stewart advising us how to boil an egg. However, a reminder about the properties of water will help a great deal.

The properties of water

Like any other substance, water is made up of molecules (a group of two or more atoms held together by chemical bonds; in this case, hydrogen and oxygen). At room temperature water takes its most familiar form. One of the fascinating properties of water is that it is transparent like glass. Even though it is crammed with millions of molecules, we can't actually see them. A standing bowl of water will appear to be quite still, but if it is left uncovered for a time the water will gradually disappear. So what is going on?

Although the water molecules appear to be stationary, they are actually on the move, similar to what happens on a snooker table when a cue ball is fired into the reds. Water molecules bombard one other and some of them 'jump' out of the surface to become part of the air. This is called evaporation. The warmer the temperature, the more quickly they move and the more molecules escape.

Conditions, such as temperature and strength of air flow, will dictate the speed of evaporation, just as it does if you are trying to dry a line of washing. When water boils, the molecules get so excited that they fly out in huge numbers and we can then see them in the form of steam. At the other end of the scale, as water gets cold, the molecules slow down and will eventually lock together as a solid and form ice crystals.

WATER AND PAINT INTERACTING

I don't know how many people use wood chip wallpaper any more but I'm sure you will be familiar with it. Textured watercolour paper, or NOT as it is known (meaning, literally, 'not pressed'), is a bit like wood chip wallpaper.

Imagine you have pasted some wood chip wallpaper to a level board. You then sprinkle some sand onto it and shake it so it evens out. All the sand will end up in the lower parts and the wood chips will be sticking up, free of sand. Now get a jug of water and pour it gently onto the paper. The water will instantly wash away the grains of sand, and leave you with a space where the water hit the paper. This is exactly what happens on watercolour paper if you reintroduce water to something you have already painted.

When paint is spread onto the paper with a brush, the water shunts the particles around. Evaporation starts immediately: the water molecules disappear rapidly, and then the paint begins to settle. The introduction of more wet paint at that point is like pouring water from the jug onto the sand; it pushes the paint away. This is exactly why watercolours should be painted as quickly as possible and not be subject to fiddling.

I'm sure you will have walked along a beach at low tide and spotted a line of seaweed at the high tide mark. This replicates what happens on the paper if you introduce more paint after you have completed a section: the water from the brush behaves like the sea and carries the paint particles away, dumping them in a line where it slows down and stops moving. This is how a watermark is formed.

HOW THE MOLECULES WORK

1 Water molecules are represented here as black dots. Imagine that they are spread out as a thin film on some watercolour paper.

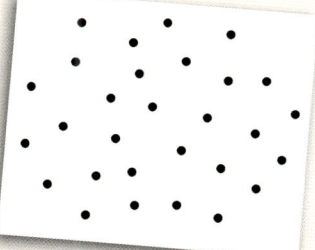

2 Water molecules at room temperate are highly active and move around, colliding with one other. Some will soak into the paper and others will evaporate.

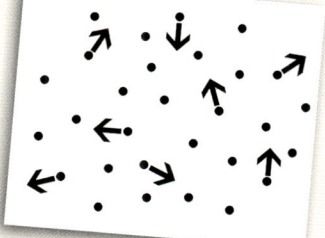

3 The red dots here represent paint particles. They are suspended in the water and are subject to some 'jostling'. They are energised by the water molecules and the whole surface is on the move.

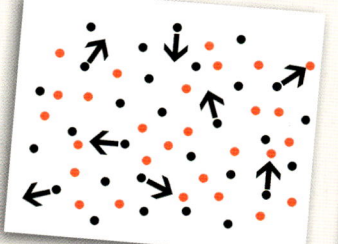

4 The energy level of the water decreases as it evaporates. This begins the moment you take your brush away. When the drying process has lapsed for a few seconds, there are considerably fewer water molecules left on the paper.

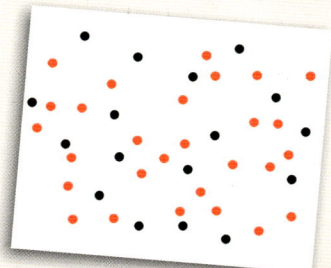

This is the point where it can all go wrong! *(Cont.)*

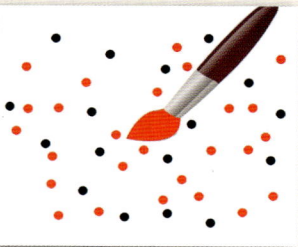

5 Not satisfied with the bit you have just painted, you return with a brush to make an improvement. This is very tempting, because we all have a need to add a final touch and do a bit more.

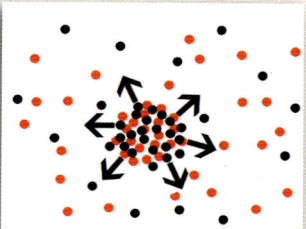

6 Unfortunately, the brush is loaded with more paint and highly energised water. As soon as you touch the panel it flows down the brush, interacts with the lower energy water on the paper and it flows outwards, away from the brush. Just like the water jug and the sand, the water picks up the paint and off it goes!

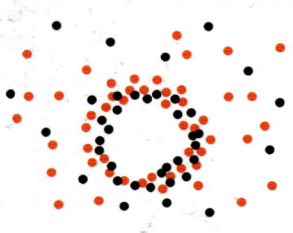

7 The water travels outwards taking the paint particles with it. Your intention to make an improvement with a final touch has only served to make things worse. Sadly, there is no way out of this. If you go back again it gets worse still.

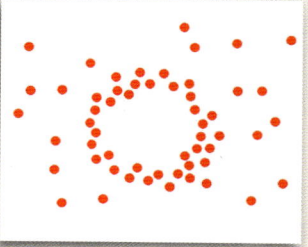

8 Once the water has evaporated completely you are left with a ring of paint. Not what you intended at all. This is a classic watermark often referred to by watercolourists as a 'bloom' or 'cauliflower'.

Hopefully, you can now see why the behaviour of the water is such an influential part of the whole process. Understanding how water behaves and getting control of it really is more important than anything else if you want to conquer this medium.

Learning how to control the water is a vital part of being a successful watercolour artist. This will be covered in the following pages.

Key ideas to take away
- Prepare and plan carefully, then change gear!
- Stroll on the palette then sprint on the paper
- Once you've painted, don't go back

WATER: FRIEND OR FOE?

As any skier will tell you, gravity is vital to the whole sport; without it the skis are useless. However, should the skier lose control during the descent, gravity will be the cause of a potential calamity. In other words, gravity is both friend and foe, depending on the control and skill of the skier.

Exactly the same can be said of watercolours. The consistency of the medium is dependent entirely on moving water, but it is that very same fluidity that can destroy what you are painting if you so happen to lose control of it. If you want to be a proficient watercolour artist, you must learn how to control the water in the brush and on the paper.

TAKING CONTROL OF THE WATER

Liquid water has a low viscosity. It flows very freely, unlike substances such as treacle or oil which flow much more sluggishly. It is this very active movement that makes water difficult to control. Many inexperienced watercolour artists find the fluidity of the paint so problematic to gauge and manipulate, that they use the paint with less water in it so that it more like acrylic paint. This may seem easier, and is appropriate for small, detailed parts like birds in the sky or for fence posts. However, it is absolutely useless for large areas where you want to create blended textures with soft edges, such as in a sky. If there isn't enough water in the paint, it will dry too quickly as it is applied. The end result will be patchy and streaky, effects which are actually created by a build up of watermarks on top of one another.

For a smooth and softly blended result, you must use plenty of water. Much more than you might think. I often say to my students 'When you think you have added enough water to the paint, add a bit more!'

Exercises One and Two will help you get to grips with the required fluidity of the paint.

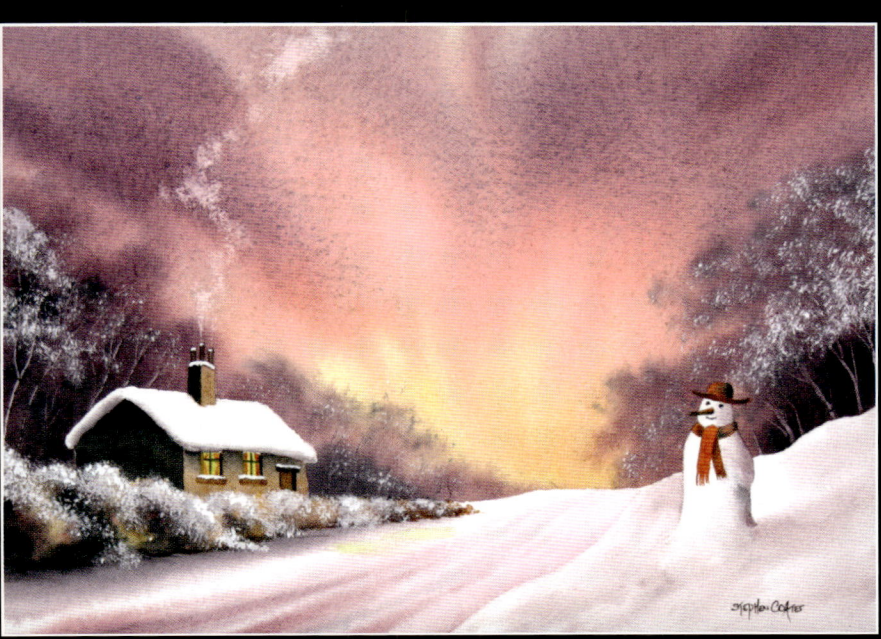

Here is a painting I did in 2012 entitled *Cosy Cottage*. I wanted to create a sky with a deep colour and a sense of distant light. I also brought movement to the clouds by sweeping the paint brush towards a focal point – in this case, the centre bottom of the picture. The whole sky is one single panel, including the soft fluffy trees in the background. The snow on the tree tops was added afterwards. It was all painted quickly with lots of water and strong paint. The brush techniques and water control were all very important factors in achieving the end result. There is, of course, a question of 'intent' with any sky like this. It will never end up exactly as intended, because of the fluidity of the water. However, to have any chance of getting close to your intentions, you will have to be armed with a good understanding of the medium and courage to learn to control the water.

Panels

There will shortly be some exercises for you to do to help you get control of the water. Before getting to that, you will have noticed earlier that I mentioned the word **panel**, something which I am going to refer to on a regular basis. Every picture painted consists of panels, so first I would like to define what a panel is.

Traditionally, a panel is considered to be a two-dimensional rectangle, much like the wooden panels you might see on the walls of a stately home. A panel has height and width but no depth. When I refer to a panel, it can be any size or shape, providing it is two-dimensional. In other words, a panel could be a square, a circle, a triangle, an oval or even just a line. The creation of depth in a painting is only an **illusion** created by the artist. You are working on flat paper, so everything you draw and paint is built up of two-dimensional panels, much like the three sections of the building below.

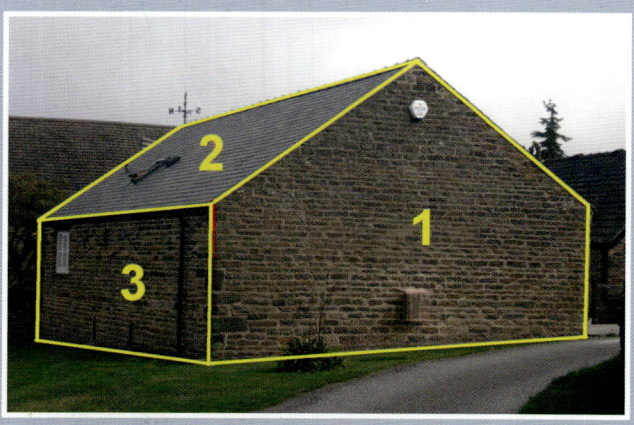
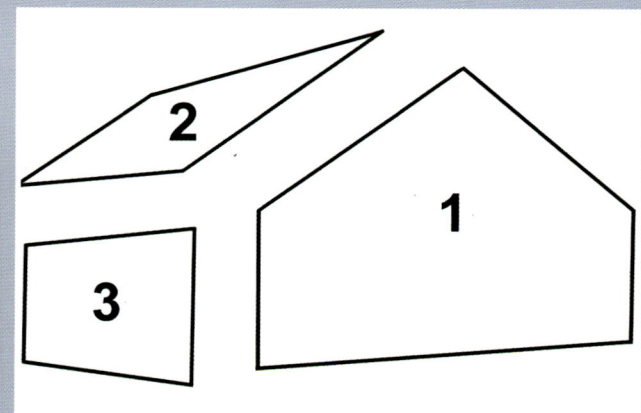

A panel is therefore any single section of a painting. For example, you would always complete an entire sky in one go regardless of the number of colours of which it might consist. It is therefore a single panel. If you are painting a small detail such as a door on a house, this is also a single panel. No matter how large or small it may be, if it is a section of your painting that you paint individually, it is a panel. Each panel in a painting will normally require different treatment, depending on what is being created; therefore, you will almost certainly use different techniques and levels of paint and water on each panel.

Key idea to take away

- The structure of every painting is built up of panels, painted one at a time in a carefully planned order.

Two principal painting methods

When paint is introduced to the paper with a brush, the panel will be completed using one of two principal methods:

Method one: Wet on dry

The panel has been painted already and has been allowed to dry, or the panel has yet to be painted at all – either way the panel is dry. This is simply known as **wet on dry**.

Wet paint is introduced to the dry panel. The fluidity of the paint needs to be quite high, because the paper absorbs some of the water quickly and the paint will dry instantly if it has insufficient water in it to start with.

Wet on dry panels are normally restricted to subjects which only require a single plain colour without variegation or blending. These would normally be details like tree branches, fence posts or birds.

Method two: Wet on wet

The panel has been pre-wet with clear water, or has paint on it which is still wet from a previous application – either way the panel is wet. This is simply known as **wet on wet**.

Proficient watercolour artists tend to use wet on wet more often than wet on dry, so it is really important that you understand what this means. If a panel requires a graduation of colour or tone, this can only be achieved if the two come together while they are wet.

Controlling the coming together of two colours or tones is known as 'blending' or 'charging'. The second colour or tone will run into the first and the paint particles will interact and mix together. For blending to occur, the panel must be wet when the second colour or tone is introduced. If it is too dry, blending will simply not happen. Gauging the exact quantities of water and paint needed to achieve this, so that you can control the outcome, is the tricky bit.

Controlling the blend

Using the wet on wet method, you will be trying to achieve two possible outcomes. Firstly, you may have two areas of wet paint which come together at a meeting point where you will blend the two together. More likely is the second situation, where you fill a whole panel with wet paint and then run another colour into it, usually from one end.

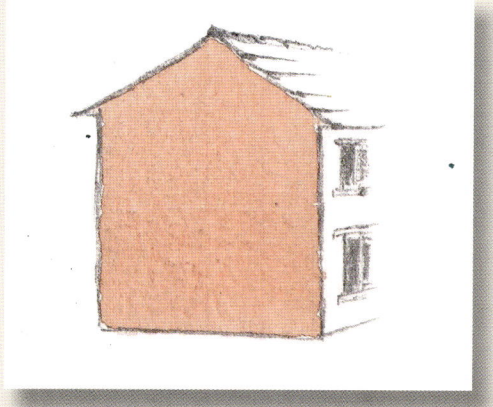

The gable end on this house has been painted with one colour directly onto dry paper. This is an example of **wet on dry**.

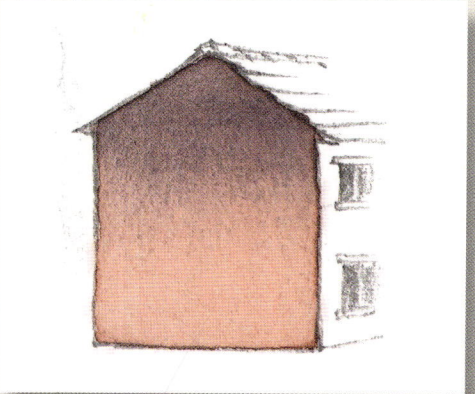

In this example, the same gable end has been painted first with one colour and then, whilst it was still wet, a second colour was introduced from the top and gently controlled and worked downwards so that a graduated effect was achieved. This is a highly desirable effect and one which most watercolour artists will favour. This is classic **wet on wet** painting.

In any situation when you are using wet on wet, the two areas of wet paint will meet and mix. However, rarely does the blend between them instantly give you the result you want. It normally needs a little assistance with the brush to control the moving water. A delicate flick or gentle sweep of the brush across the interface point of the two paints will energise the particles, encouraging them to move a little more and helping you to control the outcome.

The control of interacting paint with a brush is a very difficult action to describe, and each artist will develop his own natural feel and touch to do this. You will have a chance to practise this in Exercise Two, where you will find more information and photographs to guide you along the way. For the moment though, I have given you a description of an important and necessary action that will allow you to take control of the water in a wet on wet blend.

Wash and dab

To control the blend between two paints coming together, it is likely that you will need to use a brush to sweep or flick across the intersection point of the two wet areas. You will obviously want to use the brush that has just been used to deliver the paint into the panel. This brush will still have the second load of paint in it and will need to be washed first.

TECHNIQUE

In order to control the blend, it is vital that the amount of water in the brush is just right before it comes into contact with the panel.

- **TOO WET** and as soon as you touch the paint in the panel it will flood and wash the paint away.
- **TOO DRY** and the brush will instantly absorb paint from the panel and leave a dry white line.
- **JUST RIGHT** and the brush will neither flood or absorb water, and therefore allow you to touch the panel to control the blend.

You should always have a dry rag or cloth handy. Kitchen paper is not suitable for this because it too absorbent. Wash the paint out of the brush, dab and gently roll it on the rag to remove the excess water from the outside. This will leave the inside of the brush wet. The brush is now **neutral**. It will neither flood the panel nor drain the water away when you touch it. You should now be able to control the blend with a delicate flick or series of quick gentle sweeps without destroying it.

The action of cleaning the brush and quickly removing the excess water before returning to control a blend is an automatic action that will develop the more you practise. Some artists will use a different method of neutralising the brush – a quick flick on a sleeve, trousers or apron maybe.

The action I have described to neutralise the brush will be referred to as **wash and dab** throughout the exercises that will follow. There are plenty of opportunities for you to practise this action of blending colours, and full descriptions are provided at each stage.

The two-minute rule

Regardless of what you are painting, the time you have at your disposal to get the paint on, blend, control and remove the brush is much shorter than you might expect. Unfortunately, the evaporation of the water and the absorption of the paper combine to force your painting time into a limited period, beyond which dry brush marks and streaks will appear.

On average, the amount of time it takes for the paint particles to settle on the paper and to be at the point when there is no longer enough water for effective blending to take place is **two minutes**. This can vary according to conditions such as temperature, humidity, type of paper and the amount of water you were using initially. You might get three minutes if you are lucky, but equally you might only get one. This rule is fundamental and it is to be ignored at your peril.

What does this really mean?

Unfortunately, it means exactly what it says. Whether you are painting a huge sky or a smaller, detailed section, you have approximately two minutes to get the paint onto the paper, run in the other colours, control the blend and get your brush off! This may sound a bit stressful but I promise you it is how it is, and it is this discipline of timing that is at the heart of successful watercolour painting.

Human nature vs. laws of nature

As a human being, you are likely to have routines and order in your life, and perhaps have a tendency to fuss about things important to you. As an artist, you will bring such human traits to your work with a desire for perfection and attention to detail.

This is perfectly normal and common to all of us. However, it is this very need to add a bit more and give one final touch that can spoil what you have just painted, instead of improving it. You will have to resist what comes naturally as a human being. That is my challenge to you: once two minutes is up, **don't go back, don't fiddle and put the brush down!**

As time runs out, and you start to see the result of what you have just painted in front of you, it may not be quite as you had intended. That is the nature of watercolours. As I said before, the fluidity of the medium will always give you a slightly random result. It is at that point when the temptation to go back and fiddle is at its greatest. However, it will be better to leave it as it is rather than attempt to improve it by going back to do a bit more. These rules require significant discipline and must become a habit. I will constantly refer to these rules throughout the exercises.

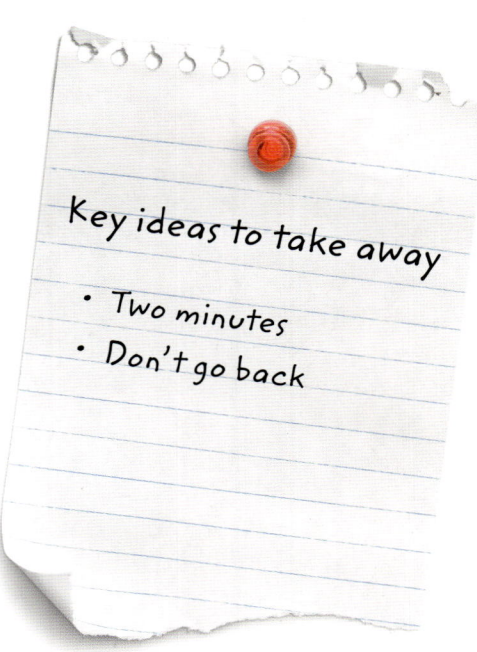

Key ideas to take away
- Two minutes
- Don't go back

What you will need

2

"As with all sports, hobbies and leisure activities, there are some important facts about equipment that you should know from the start."

Equipment and materials

A suggested list of things that you will need for each exercise will be provided at the beginning of each section. However, it is important that you get the right equipment so I will give you as many useful tips about this at each stage to help you avoid pitfalls.

As with all sports, hobbies and leisure activities, there are some important facts about the equipment used that you should know from the start. If you have sub-standard tools, you will jeopardise your chances of progress.

Paper

Watercolour paper is available in various sizes, weights, textures and qualities. The weight of the paper determines the thickness. For small exercises 190gsm (90lb) is adequate, but for larger studies above A4 (210 x 297mm or 8¼ x 11¾in) in size you need 300gsm (140lb). If the paper is too thin, it will ripple when it gets wet and the water will run into the gullies, causing all sorts of problems with the painting.

The texture of the paper will be your choice, depending on the finish you want. Most watercolour artists use NOT paper, which means, literally, 'not hot pressed'. It has an embossed surface, a bit like wood chip wallpaper. This helps to produce granulation or textured finishes for which watercolour paintings are famous. You can select the level of the texture and buy paper which is 'rough' or 'extra rough' if you require an exaggeration of that graded look. It is also possible to buy smooth watercolour paper, but it is more difficult to achieve variegated wash on a flatter surface.

There are many good quality branded papers on the market. I have settled on Bockingford NOT 300gsm (140lb) or 425gsm (200lb), depending on the size of the picture. I find the texture of the paper to be just right and the surface of the 300gsm (140lb) paper in particular is really robust. It will resist 'scrubbing', 'lifting out' and the use of masking fluid, all of which can scuff or rip more delicate or sub-standard paper.

> **! Warning:**
> Whichever paper you chose, the quality is very important. There are plenty of stationery shops which market budget-priced watercolour pads. They are often less than half the price of a branded paper. Please be very careful when purchasing these because, in my experience, budget-priced watercolour paper is usually of very poor quality, often to the point of being totally useless. Cheap paper is often too porous and uncoated, making it overly absorbent with a weak surface. It soaks up water far too quickly, so a single brush stroke dries almost instantly. This leaves you with no time at all to blend, which completely defeats the object of watercolour painting.

Brushes

Watercolour brushes are designed specifically to hold water and then allow a gentle flow through the tip. Generally, they are much softer than oil, acrylic or craft brushes. Sable is a highly regarded bristle but it is very expensive. There are plenty of good synthetic bristles on the market such as the *Prolene* range by British company Pro Arte.

Brushes are usually marked with a number. Round brushes like those shown opposite will vary in diameter. The smaller the number, the smaller the diameter of the brush. For the early exercises you will need a size 5 which is about 4mm (³⁄₁₆in) in diameter. You can use any brush, of course, but it may not do you any favours! Often, cheap brushes are not evenly tailored and a bit too soft.

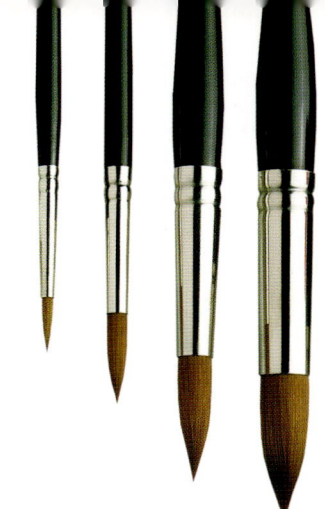

Pictured are Pro Arte series 101 round brushes. They are made from *Prolene* bristle and are round in cross section. As you can see they are tailored to a really fine sharp tip.

THE FOLIATER

Every watercolour artist needs a brush to create foliage. It is normally better to use something with a firmer bristle, and gently 'punch' downwards onto the paper to create a coarse, textured effect. This is usually referred to as 'stippling'. The Stephen Coates Foliater brushes made by Pro Arte, as pictured, have been specially designed to do this job and are available in three sizes: small, medium and large.

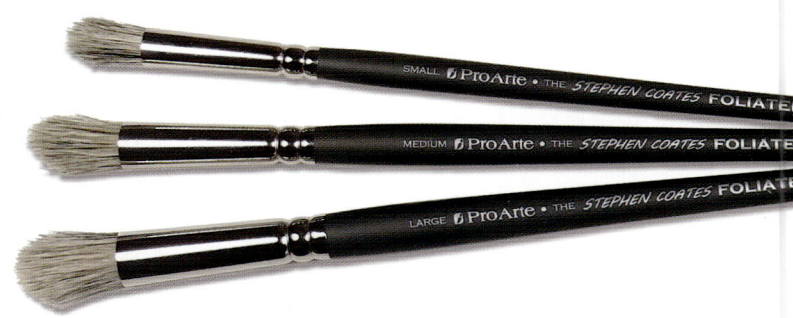

THE HAKE

The hake is a very important brush for any watercolour artist. Full details about these brushes and how to use them are covered comprehensively in Exercise Three, on pages 42–43.

Paint

Watercolour paints are basically available in two forms. They can be purchased as blocks, like small bars of soap, which you have to agitate or scrub to extract the paint particles. They are often referred to as **pan** paints, and they usually sit in a small plastic box with a mini mixing palette. The other form of paint is from a **tube**. This paint is much softer and doesn't require any work to extract the pigments.

A classic **pan** set, like the one pictured on the right, is fine for small studies or practice sessions where the panels are not particularly large. They are also very handy for travelling – perfect for a doodle while on holiday.

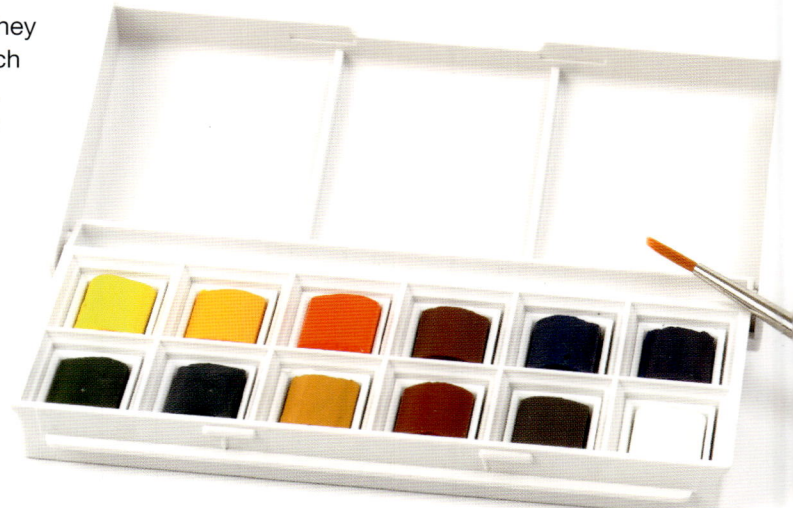

Pans are not suitable for large washes because it is almost impossible to extract enough paint to complete a large area quickly. The only other advantage with pan paints is that you get very little wastage. Once you have finished painting, you wash what little paint there is off the palette and leave the blocks to dry out for the next time.

With **tubes,** it is necessary to have a separate palette; however, once you have squeezed the paint out, you cannot get it back in. Therefore, any paint not used usually gets washed away when you have finished. You can leave it on the palette, of course, but the paint will then be dry like a pan block, and there will be little space left to mix for your next venture.

The main advantage with tubes is that the paint is soft and you can immediately get a large amount onto the palette with one squeeze. If you are creating a picture with large panels, you must have sufficient paint ready on the palette. For a large, vibrant sky it would take a long time to extract the required amount of paint from pan blocks. On the whole, I think tubes satisfy the requirements of a watercolour artist better; it is just a case of being careful when you squeeze out the paint so that most of it doesn't end up in the kitchen sink!

Cotman tubes by Winsor & Newton are good quality watercolour paints for students. There are other good brands available but, again, my advice is to avoid very cheap or unbranded products. They don't have much substance and the pigments can be uneven and weak. All good brands have a superior range called 'Artist's Watercolour'. Without doubt, they are better quality with an intensity and permanence that outshines the student paints. However, they are around four times the price and I'm not convinced that it is worth the extra, especially if you are a beginner and using the paint for practising.

There are dozens of different colours available, and most of them have incredibly fancy names which don't often relate to the shade at all. It is easy to get carried away with colours, and the manufacturers obviously want you to buy them all. Many of them are too sickly or vivid, and some are of no use whatsoever. The majority of colours that you can buy in a tube can be created by mixing other colours together; it's just a case of knowing which to use. I prefer to use a limited number of colours and learn how to mix. Not only does this cost a lot less, but mixing the colours makes it easier for them to blend together and create themes. There is an extensive tuition section about this subject on pages 71–72.

GOUACHE

White highlighting can be done with permanent white gouache instead of white watercolour paint. Gouache is a water-based paint which is much thicker than watercolour paint, and it can be applied directly onto dry watercolour bases. It cannot be loosened and used on top of dried watercolour paint, so should be used straight from the tube and for small bits of highlighting only.

Other useful equipment

WATER

To be honest, I tried hard to think of something technical to tell you about this but there really isn't anything. Any receptacle with water in it will do.

PALETTE/MIXING TRAY

The mixing palette pictured is actually a cake or butcher's tray used in catering. It has a large flat surface and is perfect for the job. It is also much cheaper than an artist's palette. A large white plate will do the trick, too.

DRAWING BOARD

A good quality drawing board is nice to have but you can use any flat, rectangular panel – MDF or plywood will do nicely. Ideally, it should be about 60 x 45cm (23⅝ x 17¾in). It will also need to be propped up so that it slopes towards you slightly. You can use a couple of books for this if you don't have a tilting mechanism of some kind. You cannot paint on a level surface because the water on the paper will tend to stand in puddles; if it does move, which is an important part of watercolour painting, you will want to know which way it will travel. Water on a level surface will move off in random directions, making it impossible to control. On a tilt, the panel will tend to dry from the top down as the water travels by force of gravity. This gives you control and helps to prevent watermarks.

CLOTH/RAG

You will need to have a cloth or rag to hand to help you keep control of the water in the brush. Later, I will show you the important **wash and dab** procedure in an exercise, which will call for a dry cloth.

KITCHEN PAPER

Kitchen paper is ultra absorbent and is another one of a watercolour artist's allies. It can be used for the removal of wet paint when required. It is also handy when you have a bit too much water and need to mop it up!

MASKING TAPE

Masking tape is an essential part of the watercolour kit. Always tape the paper to the board **all the way round the edges**. If you leave bits in order to use less tape, the edges not taped down will curl up when the paper is wet, and the water will flow underneath and into the central area of your work. This will undoubtedly create watermarks.

You can also use masking tape directly on the painting to create sharp edges. Please don't attempt this until you have completed a later exercise in this book, when you will use the tape for this purpose. There are some important tips you need to know which will help prevent the paper from tearing when you peel off the tape.

Masking tape is available from many places, and can vary a great deal in price. Once again, you will find a budget-priced product to be inferior. Cheap masking tape does not have an even coating of glue and is not very sticky. If the glue is uneven, this too will allow the paint to creep underneath the edges.

HAIR DRYER

A hair dryer is important for two purposes. Firstly, you cannot paint an adjoining panel until the previous one is dry. A hair dryer will enable you to get on with the next stage a bit sooner. Secondly, after a wash the water will keep moving the paint around on the paper. If you leave it too long it might drift further than you would want. Using the hair dryer will enable you to 'fix' the paint at the right moment.

Initial exercises & paintings

3

"It is vital that you develop a style that is confident and brisk, using as few brush strokes as possible."

Exercise One:
Feeling the fluidity

Earlier, I provided you with dictionary definitions of the three main types of artists' paint. Oils and acrylics are thick and can be made softer when diluted with white spirit and water respectively, but there is a limit to how loose they can be. Watercolours, on the other hand, are designed to be used very loose indeed.

Oils and acrylics can be applied slowly with precision, and layers can be built up gradually with a series of short brush strokes. You can return to the palette and apply a bit more paint as required and take your time until the section you are painting is completed to your satisfaction. During my years of teaching and conducting workshops, I have seen many people making the mistake of trying to apply watercolour paint in the same way as oils and acrylics. Watercolours do not respond to this method of painting, and it is vital that you develop a style which is confident and brisk, using as few brush strokes as possible.

Items you will need for this exercise

- **Watercolour paper, 300gsm (140lb)**
- **Round paint brush, size 5**
- **Watercolour paint**
 - ... *Ultramarine blue*
- **Water bowl**
- **Mixing tray**

Without painting a particular object and not conforming to anything drawn, this exercise will help you get a sense of how fluid the paint should be, and encourage you to paint swift, single brush strokes.

The idea is to load the brush with paint and see how far you can get with a continuous stroke before the brush runs dry. If you keep adding a little water and repeat the same brush stroke, you will feel a difference as you paint and see that the extra fluidity allows you to run the paint much further without it stuttering to a halt. Imagine trying to sweep gravel along a path. It would be very hard work. The fluidity of watercolours should be like sweeping marbles instead of gravel.

Key idea to take away
- Swift, minimal stroke painting and the correct fluidity is a vital combination.

The first stroke

You can work in a pad for this exercise or tape a piece of watercolour paper to a board. Just securing the corners will be sufficient on this occasion to prevent the paper from slipping.

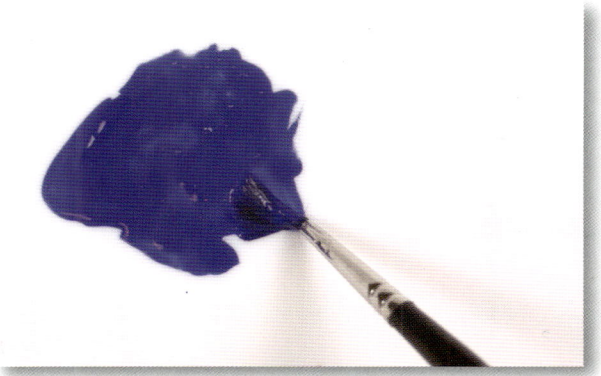

1. Squeeze a blob of ultramarine blue onto the palette, about the size of a small pea. Take your size 5 round brush and fill it up with water. Introduce this to the paint and swirl it around until it is mixed. **Use just ONE brush load of water to start with.** The paint will feel a bit sludgy and stiff.
When you apply the paint, you will need to hold the brush at a very low angle so that the side of the brush sweeps across the paper and deposits a wide stroke. The lower the angle of the brush, the wider the band of paint will be.

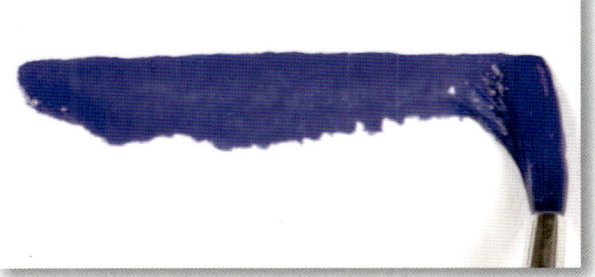

2. With a brush full of paint, and leaving yourself at least 15cm (6in) of space to work with, quickly paint a single continuous line without taking your brush off the paper. It does not need to be neat, straight or parallel. Just **one** sweeping stroke until the paint runs out!

The result should be similar to this. You will have felt the brush resist a little, and the thick paint will have run out and broken up long before you reached the end of the brush stroke. At the right-hand end of the stroke, the paint will be sitting on top of the bumps on the paper, and none of it will have flowed into the dips – hence the bits of white paper showing through.

Adding more water

The amount of water you need in the paint will vary according to what you are painting. This exercise is designed to give you a general idea about how watercolour paint should flow, and should encourage you to move the brush swiftly without fiddling or stopping.

The exercise is done by applying wet paint to dry paper, known as **wet on dry**. If you are applying the paint to wet paper (**wet on wet**), it should be premixed with less water in it or with none at all. If the paper is already wet and the prepared paint is too runny, a flood will occur and the whole lot will wash away. There will be more on this as you go through the exercises that follow.

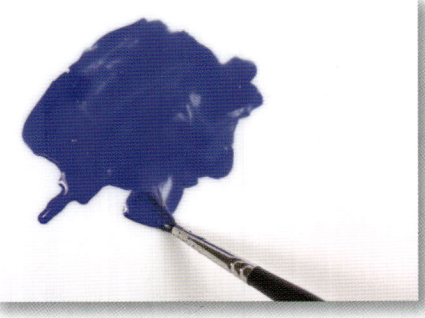 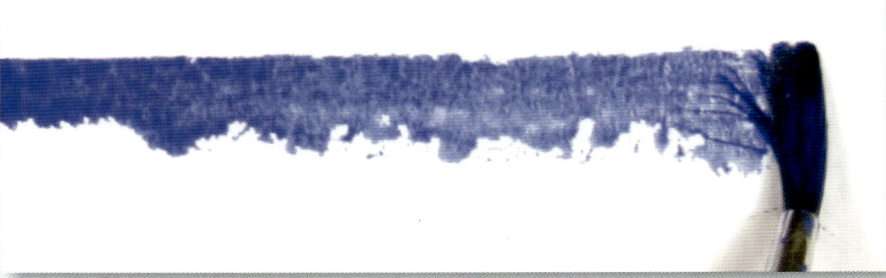

1 Add two more brush loads of water and swirl it around the paint until it is evenly mixed. Repeat the same single brush stroke at the same speed as before.

2 This time you should feel the brush glide more smoothly along the paper; it will give a better coverage and may go further before the paint runs out.

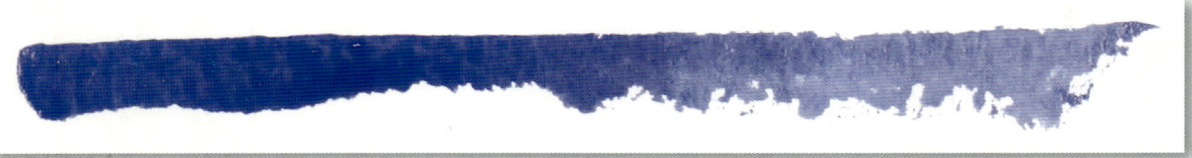

3 Add two more brush loads of water and paint the line in the same way as before. Keep doing this, adding two loads of water each time until the paint flows out of the brush and gets you all the way to the end without leaving any white paper showing (below).

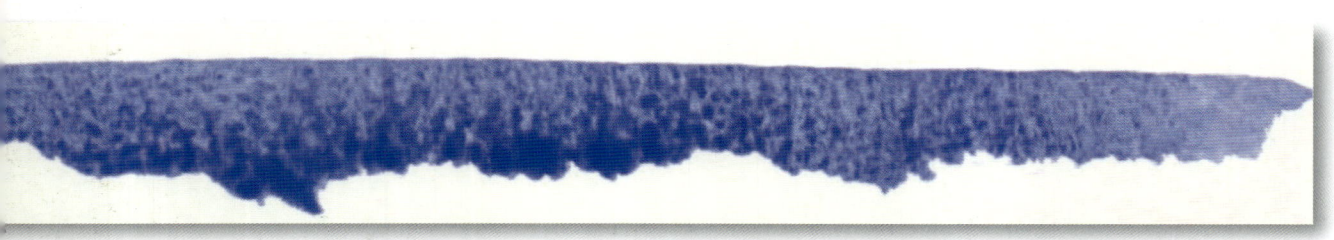

The image above took five attempts of loading the brush with water to achieve a continous, unbroken painted stroke. The amount of water your will need will obviously depend on how much paint you squeezed out and the size of brush you are using.

Try the same exercise with larger brushes. You will soon realise that you need more paint and water to complete the brush strokes.

32

Exercise Two:
Learning to blend in squares and circles

The purpose of this exercise is to help you to get a feel for how much paint and water you need, and how to create effective blending. There are a few details that I suggest you follow as closely as you can, because it is important to develop a 'touch' with the brush right from the start. This 'touch' is relevant for watercolour painting, no matter how large the composition or what size the brushes are.

Items you will need for this exercise

- **Watercolour paper, 300gsm (140lb)**
- **Round paint brush, size 5**
- **Watercolour paint**
 ... *Raw sienna*
 ... *Payne's gray*
- **Water bowl**
- **Mixing tray**
- **Cloth/rag**
- **Drawing board**
- **Masking tape**
- **Kitchen paper**
- **Pencil**

Preparing the paper

First of all, get a piece of watercolour paper roughly A4 (210 x 297mm or 8¼ x 11¾in) in size, and tape it to the board with masking tape. Place the board so that it slightly tilts towards you, at an angle of roughly fifteen to twenty degrees.

You are going to paint a whole page of small squares and circles to practise water control and blending. I suggest you draw a row of squares approximately 3cm (1¼in) square right along the top of the paper. You should fit in around six or seven squares comfortably. If you want, you can draw mutliple squares and fill the whole page, but once you have painted the top row you should be able to progress down the rest of the page without the outlines of the squares guiding you. Leave space at the bottom for drawing circles, which will follow later.

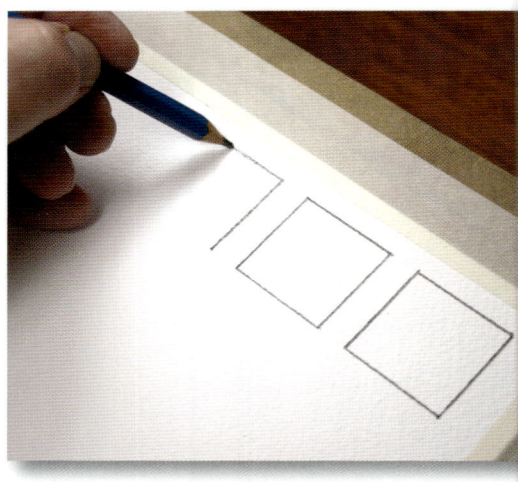

Preparing the palette

1 Squeeze a pea size blob of Payne's gray onto the palette. Put the brush into the water and feed around four brushfuls of water onto the palette next to the paint blob until you have a small puddle.

2 Put the brush into the puddle, run it towards the paint and, with a brisk side-to-side movement, pick up the paint with the tip of the brush and pull it into the water.

3 Keep doing this until you end up with a dark charcoal-coloured puddle. The paint will make the consistency of the puddle much thicker, and you need it to be fairly sludgy but still fluid. To give you an idea of what 'sludgy' means, prepare the paint so it has the consistency of double (heavy whipping) cream.

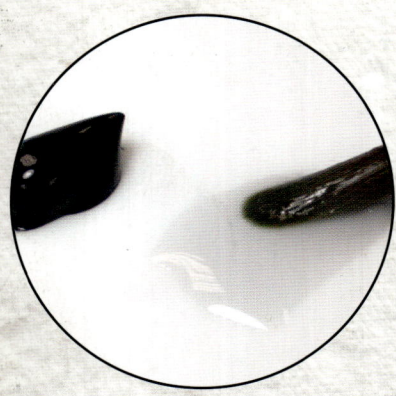

Tip
Putting a puddle of clean water onto the palette first will prevent you taking paint back to the water bowl each time and wasting it. The water will remain cleaner in the bowl as well.

Bear in mind that the required consistency of the paint on the palette will always vary according to what you are doing. Next, we will be using the **wet on wet** technique, and you are going to drop the Payne's gray into a panel that is already wet. That is why it needs to be sludgy as described: if it is too thin and introduced to a wet panel, there will be too much water and a flood will occur immediately as the brush touches the wet paper.

The preparation of the palette will always take time. It is really important to make sure there is enough paint ready to do the job. Remember, you have only two minutes so you don't have time to mess around squeezing more paint out of the tube once you have started the panel.

Wash the brush: you are nearly ready for some painting.

Wet on wet blending in a square

This exercise is going to involve filling the square with clear water and then blending a little Payne's gray into it so you can see what happens with the wet on wet technique. The idea is to try and achieve a soft, graduated blend between the clear water and the paint by controlling it with the brush.

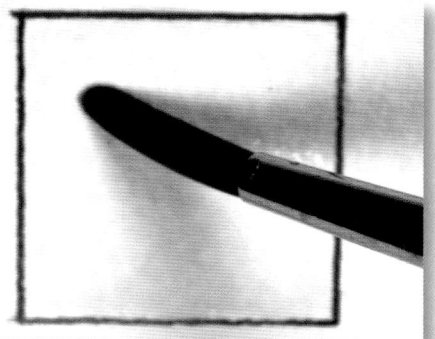
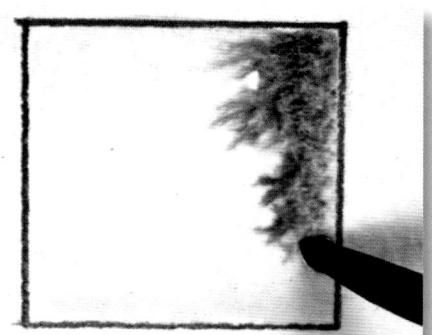
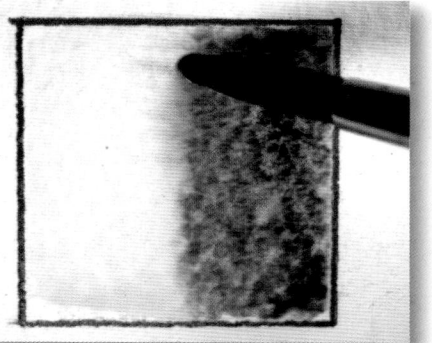

1. Start by painting clear water into the whole of the square. Make sure there are no dry patches. The water should cover the surface evenly but should not be running or pooling at the base line.

2. Now pick up a little Payne's gray off the palette and run it into the water at one side of the square. You should immediately see a feathering effect as the paint starts to blend into the water. If this doesn't happen the square is too dry, so 'punch' the whole panel with some kitchen paper. This will lift off all the paint and water and you can then start again.

3. Keep moving the brush towards the centre, adding Payne's gray until you are about half way across the square. There is now enough paint on the panel. You now need to assist the movement of the grey across the square. The brush should still be loaded with grey paint.

WASH AND DAB

4. Neutralise the brush with a **wash and dab** then gently sweep the tip of the brush up and down and across the intersection point, moving towards the clear water. This should evenly drag the gray into the water resulting in a graduated blend.

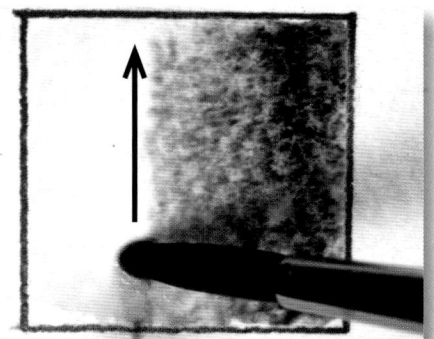
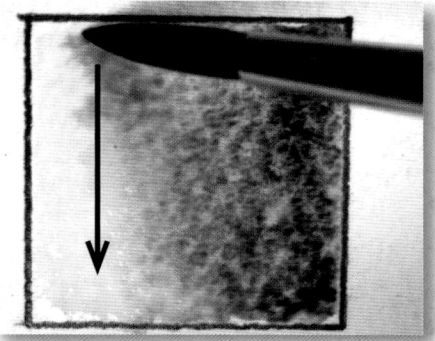

Tip

During this process, you may get a build up of water along the lower edge of the square as it slowly flows down the paper. To remove it, gently touch the water with a corner of a piece of kitchen paper. It will instantly soak away the excess water. Be careful though, you don't want to overdo it and end up with a dry white patch.

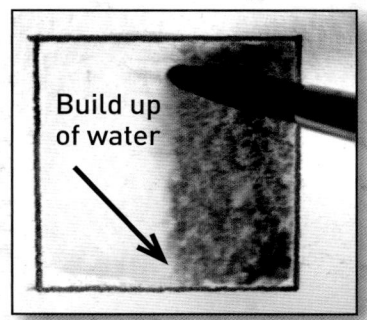

Build up of water

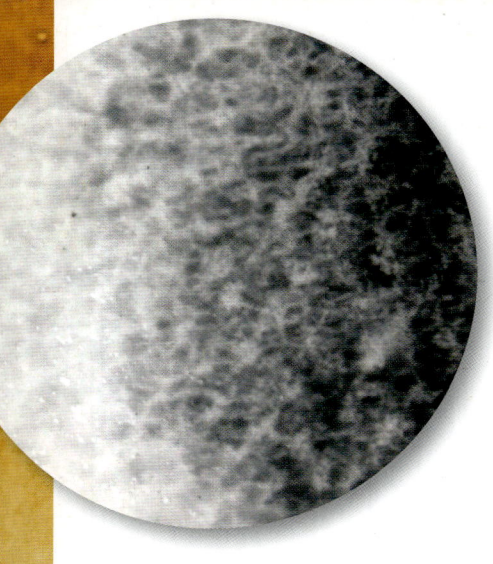

This is the classic watercolour effect that I am hoping you will achieve. You can see that the left-hand side is still almost white and the grey graduation effect works from right to left across the panel. There is also strong granulation where the grey paint particles have meandered around the bumps in the paper and settled into the dips. This will not be so obvious on pressed, smooth paper.

Repeat the exercise several times using the prepared squares on the paper. As you repeat it, you will see that each panel will be slightly different – this shows how randomly watercolours can behave. As you paint each square, you should develop a feel for the technique. You will get good squares and squares that didn't work so well. Don't worry about that though, you will gradually learn what you did that worked well and vice versa.

Introducing another colour

No you can introduce a second colour and see how that works. This time, paint the area with raw sienna instead of clear water, but still use the Payne's gray to blend across. Raw sienna is a much lighter colour, so once it is on the paper you do not wash the brush before picking up the grey.

As I described earlier, it is human instinct to dive straight for the water bowl to wash the brush before going for the next colour; however, this will load the brush up with high energy water and will flood when introduced to the panel. Don't forget, you are going to blend the two colours together so why would the brush need to be clean? Common sense really! As I describe the following process, look out for the instruction in bold: **don't wash the brush**.

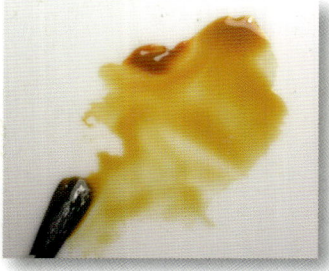
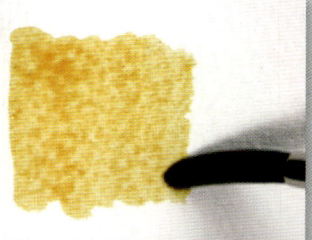
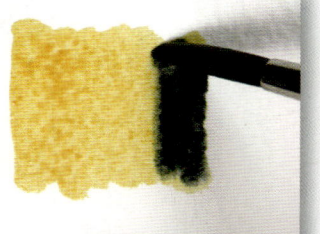
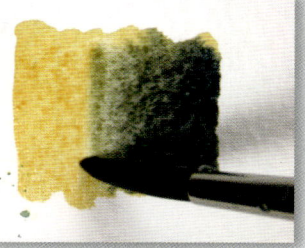

1 Squeeze a little raw sienna onto the palette and prepare it the same way as you did with the Payne's gray.

2 Paint the area with fluid raw sienna making sure it is evenly wet across the surface. You may need to go back to the palette to pick up a bit more paint.

3 **Don't wash the brush** or waste time admiring what you have done! Go straight to the Payne's gray and follow the same sequence as before: introduce the grey from one side...

4 ... then **wash and dab**, and then sweep the tip of the brush along the intersecting point of the two colours to assist the blend.

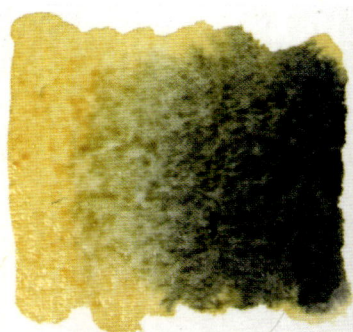

The final result.

36

Troubleshooting – wet on wet

When you are attempting to achieve graduated blends there are a number of things that can go wrong. Please don't worry if you struggle with this to start with. It does take time, practice and patience. Below are three of the most common mistakes you are likely to encounter when blending, along with the reasons why they will occur.

FLOODING, OR TOO MUCH WATER

In this picture, the two colours have been painted onto the panel. The brush has been washed – but not dabbed – and returned to the paper to perform a blend sweep with the brush as described on the opposite page. The brush was too wet and the excess water has flooded down the intersection point, taken the paint with it and formed a pool at the bottom. Once this has happened it cannot be cured. Lift it all out with kitchen paper and start again.

EMPTY BRUSH

Here the brush has been washed and dabbed, but the 'dab' was over-done. The water has been extracted from the inner part of the brush and it behaves like a vacuum cleaner. As soon as the brush tip touches the wet paint, it soaks it up and leaves a dry white line. Again, this is almost impossible to cure so my advice is remove and start again.

INSUFFICIENT WATER

Inexperienced watercolour artists will probably make this mistake more often than any other. Either the grey paint on the palette was not wet enough, or there was insufficient raw sienna painted onto the panel to start with. The attempted blend fails, and the end result is a series of dry brush strokes and stripes with hard edges.

Wet on wet circles

In preparation for the exercise opposite, which involves painting pebbles, have a go at painting circles instead of squares using the same principles as earlier. The idea is to convert the circle into something which looks spherical like a stone. Imagine there is a source of light coming from the right-hand side; the part of the sphere away from the light will be much darker. Therefore, it is important to perform a graduated blend in a circular way, in order to make the surface look curved. Practise painting several circles; you will get better the more you do.

1 Draw a rough circle about 5cm (2in) in diameter. Pick up some raw sienna and fill the circle, ensuring it is evenly wet across the surface. Remember, if it is too dry a blend will not occur. **Do not wash the brush.**

2 Immediately, pick up some Payne's gray and start filling in the circle from one side until the shade is about half way across. Try to round the edges a bit, which will help it to look spherical.

3 Once there is enough grey on the circle **wash and dab** the brush. Gently sweep the tip across the intersection point to create a gradual blend. Don't be too worried about it being perfect. If you fiddle it will spoil.

The final result.

38

Exercise Three:
'Pebbles on the Sand'

Earlier, we examined the properties of watercolours and discovered that the paint pigments are not permanent. This means that it isn't possible to paint light colours over the top of dark ones.

There are actually two reasons why this is the case. Firstly, because the pigments are in suspension they are not particularly dense. This means the dark paint underneath will show through, much like if you were putting a light-coloured emulsion paint over a darker colour on a wall in your home – you know it will take several coats to cover the darker paint, depending on its quality or thickness. Secondly, because watercolour pigments are permanently soluble, the moment you stroke a wet paint brush containing a light colour over a dark section, the water activates the dark paint particles underneath and the two colours will start to mix together. The result will be a murky version of the light colour you were trying to paint over the top. When you work the other way round, painting dark colours over light ones, the same thing happens; however, the light colour underneath will not be strong enough to show through.

This situation is unique to watercolours, and it means that you always start with the lighter tones and work towards the darker ones as you progress with your picture. This often dictates that you will have to paint 'in reverse' or **negative**. More on that later.

Key idea to take away
- *Working from light to dark tones means you will need to plan ahead.*

Items you will need for this exercise

Warning: Please read and digest all the instructions at each stage before proceeding with the painting.

- **Watercolour paper, 300gsm (140lb)**
- **Brushes**
 ... 2.5cm (1in) hake
 ... Rigger
 ... Two round paint brushes, size 5 and size 8
- **Watercolour paint**
 ... Raw sienna
 ... Payne's gray
 ... Burnt umber
- **Water bowl**
- **Mixing tray**
- **Cloth/rag**
- **Drawing board**
- **Masking tape**
- **Kitchen paper**
- **Pencil**
- **Toothbrush**
- **Small ruler**
- **Hair dryer**

Making a plan

Although most people just want to get on and paint a picture, it is important to understand that time spent planning ahead is invaluable. It involves examining the panels that make up the composition, and deciding in which order they should be painted. There will be many occasions when you become stumped during a painting, and realise you have painted panels in the wrong order. This can ultimately ruin your chances of a successful painting, therefore planning ahead will prevent such moments occurring.

This exercise has been specifically selected to give you an early lesson in the importance of planning. I advise that you go through this process before starting any watercolour painting.

Planning 'Pebbles on the Sand'

The first question to ask is: what comes first, the sand or the pebbles? If the pebbles are painted first, the sand would then have to be painted around them. The time you would take to paint carefully around the pebbles would result in a patchy finish, with dry brush strokes around the edges. It would also be impossible to add paint speckles onto the sand without getting them all over the pebbles. The sand must therefore be painted first, with a continuous wash which covers the pebbles. Likewise, the speckles are created by spraying directly onto the whole area of the sand. Once this is dry, the paint (including the speckles) can be carefully removed from the pebbles with a wet paint brush and some kitchen paper. The pebbles, shadows and detailed features can then be added.

The successful execution of this plan is dependant on the quality of the paper. There are some brands of budget-priced paper which are not well coated and are over-absorbent. The paint will penetrate so far into the paper that it will be impossible to lift it off again without damaging the surface. I would advise you to run a test on the paper you are using first, to make sure the paint will lift off successfully, before attempting to paint the picture.

THE ORDER

1. Draw the pebbles.
2. Paint a wash for the sand.
3. Speckle the sand.
4. Lift out the pebbles.
5. Paint each pebble.
6. Paint the shadows.
7. Finishing touches.

Assembling your equipment

For this study you will need a few extra items. Use a size 8 round brush to paint the graduated blends on the pebbles and a size 5 for painting the shadows. A rigger is used for the detailed features on the pebbles. You will need a 2.5cm (1in) hake to paint a wash for the sand and then any old cheap toothbrush will do for creating the grains of sand. A small ruler, or something with a straight edge, will be required to assist with the flicking process to get a fine spray out of the toothbrush.

The rigger

This is a small round brush, with much longer bristles and a much sharper tip than the standard round variety. These long bristles act like a reservoir and enable the artist to deliver longer, continuous strokes without returning to the palette for more paint – providing the paint contains plenty of water. If the paint is thick or semi-dry, the rigger will not work. The brush literally gets its name from its use in painting ship rigging, and is typically used for super-fine lines.

The hair dryer

A hair dryer is another essential piece of equipment. When you have completed a large wash like the one you will make or 'lay' in this exercise, any moving water on the surface may continue to drift. If you leave it to dry naturally, the paint can end up moving further than you want. It may be that the wash is perfect at a certain point and you don't require any further movement. Also, the slightly distorted paper might hold semi-dry puddles of water which will gradually soak across into the dry areas and leave undesirable watermarks. A good blast with the hair dryer will quickly 'fix' the wash and it also means you can get on with the next panel much sooner. If you are a little impatient like me, that's a really good thing!

The hake

The hake is an incredibly important watercolour brush. As you can see from the picture, it looks oriental in design and not at all like a traditional fine art brush, and they do in fact originate in the Far East. What is important is that the brush is made of goat hair. These bristles are fine and soft, which gives the brush an incredible capacity to hold and deliver lots of water quickly. Another advantage with the softness of the bristle is that it can be used to produce extremely delicate blends with feathery edges.

Given that you have a maximum of two minutes to complete a wash, it is obvious that a small brush is not practical for panels like skies or large background areas. It is therefore essential to use a larger brush in order to complete these panels quickly. This is where the hake comes in. You can deliver huge quantities of paint and water onto the paper in a very short space of time, thus allowing you to conform to the two-minute rule.

The profile of the hake is another bonus. The whole bristle head is shaped like a chisel. This enables the artist to paint wide, parallel strokes and use the full width of the brush. Varying the angle of the brush head will help to produce brush strokes of different widths: turning it often within the same brush stroke helps produce tapered lines, and using it sideways creates sharp, narrow lines. When the hake is wet, the whole brush head can be flattened by squeezing the bristles between the fingers until it is like a knife edge. When it is a little drier, the bristles will open up and become a bit spiky. This is no good for washes, but in this state it can be used to paint foliage, grasses and reeds.

In my view, the hake is the most versatile brush a watercolour artist can own. If you don't have one, I would advise you to buy one immediately. They are not expensive and will last for years if you look after them. There are several brands of hake on the market and they are available in different sizes. I would recommend that you have two brushes, 2.5 and 5cm (1 and 2in) in width. Avoid hakes which are very bushy: they will not allow you to produce thin, chisel-like edges because there is an excess of goat hair packed into the head of the brush.

USING THE HAKE TO PRODUCE A BROAD WASH

The hake is a delicate brush and should be used as gently as possible. You do not need to press on the brush and only the first two or three millimetres of the tip should be in contact with the paper throughout the whole brush stroke. As you sweep the brush across the surface the water will flow downwards and out onto the paper. If the brush is too dry, the water will not flow and you will not be able to create a large variegated wash.

Only 2–3mm should be in contact with the paper

water flow

42

THE FEEL OF THE HAKE

Hold the hake softly between thumb and fingers as shown and allow your wrist to rotate. This will allow you to create shorter brush strokes when necessary.

For a larger wash, move the hake back and forth in long sweeps using your whole arm, remembering to keep the touch very light.

When creating smaller features, such as individual clouds, the hake should move in a series of short flicks in the same direction, lifting the brush away each time. For broad areas, keep the hake square to the paper but when you want to taper off, change the angle of the brush so that only the trailing corner of the bristles touches the paper.

The exercise

Stage 1: Initial drawing

1. Tape a piece of A5 (148 x 210mm or 5¾ x 8¼in) size watercolour paper to the board all the way round in portrait format. Now draw the outline of three pebbles, as shown in the picture in Step 2. You can also draw the lines which define the position of the shadows.

> **TIP**
> Smaller studies like this are recommended as a beginner, especially if you are using a hake for the first time.

Stage 2: Creating a wash

2. You are now going to create a wash. Squeeze a pea size blob of raw sienna, Payne's gray and burnt umber onto the palette, leaving plenty of space between them. Soak the hake in the water bowl and make sure it is wet all the way through the bristle head. If the central part is dry, the hake will not deliver enough water. Using the hake, wet the paper with clear water in wide gentle sweeping strokes. You want an even covering of 'shiny' water without any running down in little streams. If you see the water running, just keep passing the hake across the paper until the water stabilises. Once you have the right amount of water on the paper, **do not return to the water for the remainder of the entire wash** – including the application of the paint.

> **TIP**
> Wetting the paper first extends the time you have to perform the wash. Until paint is introduced, you have as much time as you like to get the water even. The clock doesn't start ticking until the first colour is dropped onto the paper. Some experienced artists will wash straight onto dry paper, with the first colour on the brush: although this can work perfectly well, it does mean that the artist has to work even more quickly.

3. Now, without returning to the water bowl, take the hake and pick up some raw sienna onto the tip of the bristles, using a swift side-to-side motion. Turn the brush over and repeat until the paint is evenly distributed across the width of the bristles. You don't want any lumps of thick paint anywhere on the tip.

4 Hold the hake sideways on and gently sweep it from one side to the other across the whole paper, working from top to bottom. Make sure the brush strokes go over the masking tape. If you stop short of the edge it will leave flat brush marks within the wash. If the paint is patchy, whip the hake across the paper a few times from side to side, travelling up to the top and down again. So long as you do this quickly, and there is still plenty of water on the paper, any uneven lines will soften.

5 **Do not wash the brush**. Go directly to the palette and, in the same way as before in Step 3, pick up a little burnt umber onto the tip of the hake. Not too much to start with!

6 Use exactly the same motion as you did with the raw sienna, and drift the burnt umber across the whole area. Repeatedly, but very softly, sweep the hake across and even out the brush strokes. Don't overdo it otherwise the whole panel will end up one colour. The idea is to create a blended, variegated wash which will suggest different textures and slight undulations in the sand. Providing you still have enough water on the surface, any strong lines should ease off and soften after you have taken your brush away. You have now finished with the hake.

7 Now give the whole thing a thorough dry with a hair dryer, taking care not to shoot excess water around the edge and back into the wash.

TIP

If there is water standing on the masking tape, it a good idea to mop it up first with some kitchen paper before using the hair dryer.

At this stage, the speckles on the wash that simulate grains of sand are made by spraying tiny paint droplets onto the surface using a toothbrush.

TECHNIQUE – USING A TOOTHBRUSH

Loading the toothbrush with paint and then pulling the bristles back sharply in the direction of the arrow, as pictured, will release them so that each bristle throws a tiny droplet of paint onto the paper.

The toothbrush needs to be held at an angle of about thirty degrees in order to hit the target area. You will need a hard-edged instrument to pull back the bristles – a small plastic ruler or a credit card is ideal for this purpose. Some artists use their thumb or fingernail but, in my view, you don't get the required amount of accuracy or control that way.

<u>Please practise this first.</u> Use any old bit of paper to test your technique. It does take a few attempts to get the hang of it, so please don't spoil your painting with the first try.

Stage 3: Creating the grains of sand

8 Now you are going to create the grains of sand on the beach. Dip the bristles of your toothbrush into the water and then drag out some burnt umber from the paint on the palette, swirling it round until the bristles are full of wet paint. Then, hold the toothbrush at an angle of about thirty degrees and pull the ruler back sharply. The resulting spray should flick down towards the paper, and you should be able to guide it to the desired area. You will only get a small amount of spray each time, so you will have to be patient and keep returning to the palette for more paint. If the paint is too wet you will get big blobs on the paper, so be careful. Equally, if it is too dry it won't come out of the bristles at all.

9 Lightly cover the surface with speckles and then dry it with a hair dryer. Add another layer of speckles, and dry this with the hair dryer. Continue to add speckles in this way, getting a bit darker with each one. You could add a little Payne's gray for the last layer to add contrast. Sand is made up of different coloured grains so the variation in intensity and colour will help make you painting look more realistic.

TIP

If you spray too many droplets in one go, they land on top of one another and run into each other, forming large, wet blobs. Drying between layers will ensure each droplet will look like an individual grain of sand.

Stage 4: Lifting the paint off the pebbles

The pebbles are now completely covered with paint from both the wash and the speckles. It is necessary to remove this paint in order to create white or light-coloured pebbles. Providing you are using a good quality paper, the paint should lift out. The principle behind this is that watercolour paint particles are not permanent and, if you introduce water to the pebble panels, the particles will re-suspend and can be removed with kitchen paper. Make sure you have dried the whole picture before you start this.

10 Take the size 8 round brush, fill it with clear water and stroke it across one of the pebbles with a slight scrubbing action.

11 Immediately, hit the wet area with a single dab of scrunched-up kitchen paper. The paint should have re-suspended in the water and the kitchen paper should take out the whole lot.

12 Repeat this action until all the paint has been removed. You should now have exposed the white paper underneath in the shape of the pebble.

13 When you have removed all the paint from the pebbles, you will likely see the pencil lines from the initial drawing. Make sure the paper is dry before using an eraser to remove these lines. What you should have now is a speckled wash looking like sand with three white holes in it, rather like some jigsaw pieces are missing. You may wish to re-draw the lines for the shadows if they have disappeared under the paint.

47

Stage 5: Painting the pebbles

All the practice you did in the second exercise will now come into its own. If you haven't tried Exercise Two (see pages 33–38), you might not fully understand some of the terms used in the instructions for the next part; therefore, I would advise you to complete that exercise before trying this one, as it will help enormously with the the following stage.

As you can see, the three pebbles are different colours: light brown, grey and white. The same technique is used on each one, it is just the colours that are different.

> **Warning:**
> Remember to prepare the palette before painting at each stage. Watercolours will dry up very quickly, and by the time you get to the next stage the palette will need refreshing. Make sure the burnt umber and Payne's gray are reasonably fluid – it is no good if they have become crusty.

14 Continue with a size 8 round brush. Start by dragging some burnt umber out onto the palette and adding water until it is pale. Fill the small pebble with this, creating an overall creamy colour. **Do not wash the brush**.

15 Immediately pick up some thicker burnt umber in the tip of the brush and introduce it to one side of the pebble. Drag it across into the paler paint. **Do not wash the brush**.

16 Go straight to the palette and pick up a little Payne's gray, and brush the shade into the far left-hand side of the pebble.

17 You now need to give each colour blend a hand and smooth them all out. The whole pebble should still be wet. Having neutralised the brush with a **wash and dab**, gently sweep the very tip of the brush along each intersection point of the paints to encourage a soft blend across the pebble. Don't fiddle with the painting once you have blended in each intersection: the pebble will be drying and you don't want dry brush marks. Take the brush off the paper and let the water do its job.

18 You can now repeat this process using different colours for the other pebbles. The central pebble needs to be painted first with weak Payne's gray and then blended with a stronger grey. The largest pebble should be painted with clear water and then blended with Payne's gray from the left. Even though this pebble will have a lot of Payne's gray in it, providing you leave the far right clear it will still look white! Hopefully, you will now have three shapes that look reasonably spherical. Ensure the whole painting is dry before the next step.

Stage 6: Painting shadows

The shadows need to be dark, so should be painted with a strong Payne's gray. The paint should be fluid but rich in colour, and there needs to be enough ready on the palette to complete the job. Please use a piece of paper first to test the intensity of the grey before committing it to the painting.

19 Pick up the size 5 round brush. The panels are a little smaller, and there are some sharp corners to paint which will be more manageable with the sharper tip. Fill the brush with paint and start at one end of the shadow. Carefully work your way along, filling the area as you go. Do not let your brush dry up. Keep returning to the palette for more paint and carry on where you left off. The paint you applied already will be drying quickly so **don't go back** or it will go streaky.

Stage 7: Painting feature lines with a rigger

Once the shadows are complete, it is just a matter of painting a few finishing touches. For super-fine feature lines you will need a tiny brush. Size 0 or 1 standard brushes will give you a fine, sharp point to work with but they don't hold much paint because the bristles are so short. It is preferable to paint long, fine feature lines in one brush stroke so that they are unbroken. This is where the rigger comes in.

20 Refresh the Payne's gray on the palette by adding water to it using one of your larger round brushes. Mix it round until you have a nice large puddle of dark grey. Now swirl the rigger round in the puddle of paint and have a little try on some test paper first, to make sure you have the correct shade and thickness.

21 Use the rigger to paint fine feature lines on the pebbles. If you try and produce gentle curves especially at the ends, it will look like the lines go all the way round and will help sell the illusion that the pebbles are three-dimensional spherical shapes.

TIP
Always have a small scrap of watercolour paper handy. I recommend you stick it to the board near your painting (I use sticky tack or tape), otherwise it will fly off when you switch on the hair dryer. You can then check that the intensity of the paint is just right before committing it to the painting. If you make a mistake with these fine lines, they will be almost impossible to remove.

You have finished the picture, congratulations! Who said watercolour painting was relaxing?

If you enjoyed painting the pebbles and produced a good result, you can always do another and challenge yourself a little: the painting above on the right is one I did a few years ago. I used masking fluid to protect the pebbles in this one, simply because there were so many of them and I decided it would be quicker than lifting off all the paint by scrubbing and dabbing with kitchen paper. The shadows were painted onto the sand before spraying with the toothbrush, while the masking fluid was still on the pebbles. The shadows cast onto the pebbles were painted at the end. There are a few more features on the pebbles and you can also see a few glints of light in the sand. These are little dots of white gouache, added to look like little bits of shiny quartz. Otherwise, the process is exactly the same as the exercise you have just done.

The use of masking fluid, including some warnings about the product, is fully covered in Exercise Six on page 79.

Exercise Four:
'Across the Bay'

The painting for this exercise is of a beach with a view of the bay (turn to page 58 to see a larger image of the final piece). It is quite minimal so that you can practise the necessary techniques without getting bogged down with too much detail. To simplify things even further, there are only two colours used: raw sienna and ultramarine blue. It is amazing how effective a picture like this can be even though there is very little content in the composition.

Items you will need for this exercise

- **Watercolour paper, 300gsm (140lb)**
- **Brushes**
 - ... 2.5cm (1in) hake
 - ... Two round paint brushes, size 2 and size 5
- **Watercolour paint**
 - ... Raw sienna
 - ... Ultramarine blue
- Water bowl
- Mixing tray
- Cloth/rag
- Drawing board
- Masking tape
- Kitchen paper
- Pencil
- Small ruler
- Hair dryer

! Warning: Please read and digest all the instructions at each stage before proceeding with the painting.

51

Panels and planning

Let's start by counting the panels. The sky is the first and most obvious panel. Painting this requires some forethought and planning in itself (more on that in a moment). If you paint the sea as one panel and then the beach as another, there will be a hard line where the two meet. You can clearly see in the painting that the intersection point between the beach and the sea is soft, and forms a gradual blend rather than a definite line. This is because, in reality, if you look out towards the sea from a low angle like this the waterline is always indistinct, as it is a long distance away and makes the water looks almost shallow. Therefore, it would look unnatural if it were painted with a hard line.

In order to get a soft line, the sea and sand have to be painted while they are both wet and then blended together where they meet. Effectively, this means that the beach and sea are one single panel. The two distant headlands across the bay are next and should be painted separately. That makes four main panels, plus any detailed bits that you might want to include – I have painted a romantic couple, some shadows and a pair of soaring gulls. Multiply this number of panels by the two minutes per panel limit we discussed earlier, and this gives you a maximum painting time of approximately eight minutes, plus the extra details!

Bear in mind that you will spend more time sketching, planning, preparing the paint on the palette and testing the colour, than you will actually painting the picture. This is normal for most watercolour paintings.

Making a preliminary sketch

An important part of forward planning is the production of an initial drawing. Sketching the position and tonal value of all the light and dark areas allows you to prepare for the task ahead.

This is particularly useful when you apply the paint for the sky. Remember, you only have approximately two minutes to paint the whole sky so the better prepared you are, the greater the likelihood of success. You can draw the horizon and distant features, but you cannot put any pencil markings in the sky area because they will show through the paint afterwards. You are therefore painting freehand, so having a sketch at the side of your painting throughout will help you to guide the brush and remind you of the tonal values of the paint.

Key idea to take away

- An initial sketch is valuable in understanding the tones that will appear in the piece.

The exercise

Stage 1: Initial drawing

1. Tape a piece of A5 (148 x 210mm or 5¾ x 8¼in) size watercolour paper in landscape format and tape it to the board all the way round. Using the finished picture on page 58 as a guide if necessary, draw the horizon a quarter of the way up the page. When you do this, you will probably feel that there isn't enough room for the sea and beach – let me reassure you that there is, so don't be tempted to draw the horizon higher. Draw the headland closest to you, taking care to leave it short of the centre, and then draw the distant headland smaller and fainter, making sure it goes beyond the centre. Sketch these panels lightly; if you draw the headlands too dark, the pencil line will show through the paint afterwards.

Stage 2: Creating the sky

This panel features wispy cirrus clouds gently blowing across the blue sky. Naturally, most of us would want to paint the sky first and then lay the clouds on afterwards. Unfortunately, this isn't possible because you are working with watercolours. You will have to put a little raw sienna on first to give the clouds a slightly creamy colour and then create the clouds by sweeping the blue paint across in the right places. In other words, you will have to concentrate on the shape, size and position of the clouds while you are painting the blue sky.

Welcome to the world of negative painting! This is quite common in watercolour painting, and it is why an initial sketch can be so helpful: there is a lot to think about and only two minutes to perform the whole area. In some respects, this might feel a little daunting or stressful; but look at it as challenging and exciting – for me, it's what painting skies in watercolour is all about! Remember: the more you do, the better you get. Good luck!

Tip
The blue should be more intense at the top of the sky, because skies always fade towards the horizon. In addition, the bands of clouds should become narrower towards the horizon to give a sense of distance, and accurately capture the perspective in the painting.

2. Squeeze a blob of raw sienna and ultramarine blue onto the palette, leaving plenty of space between them. Soak the hake in water and sweep it across the whole sky. Make sure there is an even film of water on the paper and that you wet below the horizon line. Have a look at the paper at an angle if necessary, so that you can see the shine. Take care not to over wet the paper.

3. Pick up a very small amount of raw sienna on the tip and gently pull it across the whole sky area. Do this quickly and move on but **do not wash the brush!**

4. Now put the hake directly into the ultramarine blue, taking care to get an even coverage along the tip of the brush. **Do not pick up too much to start with**; you can always add a little more but you can't take it out. Using your preliminary sketch as a reference, direct the hake across the paper where you've determined the blue sections of the sky are. Try and turn the hake in your hand as you go and make zigzag movements to give the clouds irregular edges. If you have insufficient paint at the top, you can pick up a little more and run it across, providing you have time. If the water has lost its shine and your two minutes are up, don't add any more. Resist fiddling any further and **don't go back**. Mop up any excess water round the edge or below the horizon with some kitchen paper and then dry thoroughly.

Stage 3: Painting the sea and beach

The sea and beach should be painted quickly so that the two colours softly blend together where they meet. However, the horizon should also be really sharp and straight. This is almost impossible to achieve when painting so swiftly, but using masking tape will make this easier.

5. Stick masking tape to the painting along the horizon line and press down firmly along the sealed edge to make sure the paint cannot seep underneath. You can now paint confidently over this edge, as you will have a perfectly straight horizon once the tape is removed. Make sure you follow my tip further on before peeling off the tape.

6. Using a size 5 brush, introduce plenty of water to the blue on the palette and swish it around until you have a puddle that is the correct strength for the sea. Use a scrap of paper to test this if needed, and check there is enough paint on the palette to complete the whole sea area. You are going to apply the raw sienna with the hake as quickly as possible, and then immediately paint the sea with a size 5; if you run out of the blue halfway through, you will not have time to mix any more. Again, you will need to work as quickly as you can to ensure that the raw sienna is still wet when you get to it. If it has dried, it will not blend.

7. With the semi-wet hake, pick up plenty of raw sienna and drag it as quickly as possible across the paper, leaving a dry band approximately 1cm (⅜in) wide just below the horizon. This paint must be fluid and shiny.

54

8 Immediately pick up the size 5 round brush, load it with the ultramarine blue and run it along the edge of the masking tape from one side to the other. Don't let the brush run dry and keep picking up paint from the palette.

9 Run another line of ultramarine blue underneath, leaving small gaps of dry white paper to look like breaking waves. Keep picking up paint from the palette and work as quickly as you can. Repeat this until you meet the beach.

10 Run some blue right along the top edge of the raw sienna and if it is still wet, it should blend. Quickly **wash and dab** the brush.

11 With the brush neutralised, you can gently flick it across the intersection of the sea and the beach to soften the blend. Dry thoroughly and then remove the masking tape (see below for advice on how to do this).

TIP

To remove masking tape, simply blow warm air onto the piece using the hair dryer: the heat will loosen the adhesive. Slowly follow it across as you peel it off and you should find it comes away easily without leaving any sticky residue behind or tearing the paper.

If you notice paint has leaked underneath, either your tape is defective or you didn't press down hard enough when you applied it.

55

Stage 4: Painting the headlands

There are two headlands in the painting, one of which is much further away. You will need to prepare two separate pools of ultramarine blue on your palette, one much stronger than the other: to do this, simply add a little more water to one of the blues to weaken the colour. Test them on a piece of scrap paper first and again make sure there is enough paint to complete each section.

What to avoid

The natural way to paint a headland like this is to carefully run the brush along the ridge first making sure it is neat and the right shape; you would then perhaps fill in the rest. This creates a **danger point.**

The ridge dries very quickly and when you go back to fill in the rest of the headland, the paint on the brush is wetter than the ridge. This will create an undesirable watermark.

You can clearly see the end result: a watermark has appeared along the full length of the ridge. This becomes more obvious once it dries.

The correct technique

To prevent this problem, start at one end and work your way along picking up a little paint as you go and not allowing the brush to run dry. Once you have moved along, **don't go back!**

As you paint the headlands, try to keep your brush strokes moving in the direction of the natural contours. If any marks do appear, they will be helping to shape the lay of the land.

12 With a size 2 brush, pick up a little of the weak blue and run the paint along as previously described. Don't go over it and fiddle as it will create watermarks. Dry this before painting the next one otherwise it will bleed across.

13 Repeat this with stronger paint for the near headland and use a size 5 brush. You should always use bigger brushes for larger areas to help you paint them more quickly.

Stage 6: Final details

At this point you can choose to add small figures in your picture. However, bearing in mind the composition of the painting, they will need to be tiny; this makes it impossible to define details such as arms, feet and hands. In the detail below, you will notice the figures are little more than parsnip shapes stood on end with a dot for a head.

14 Use a size 2 brush and practise painting several figures in a row. Vary the shape and colour, and you will be amazed at how human they will look. Always practise painting the figures you have chosen before committing to your painting. Once you are happy with your technique, add two figures to your painting.

The same principle applies to birds. Use a rigger and practise first. You don't want to spoil your picture right at the end by painting a pterodactyl!

57

The finished painting.

Exercise Five:
'Red Sail Reflections'

This is a tranquil scene depicting a tiny sailing boat that has been out at sea and is returning home for the evening. Unfortunately for the sailor, the wind has dropped and his sail has gone a bit floppy! Hopefully he has some oars on board.

The key features of this painting are what makes it so attractive. Firstly, there is no horizon, which makes the background look soft and hazy, and its wash gently graduates from dark grey at the base to a light pinkish red at the top without any discernible lines, apart from a few soft ripples in the foreground. The boat is also set slightly to the left and is balanced by the two headlands cutting in from the right. Finally, the sail dominates the vertical plane of the composition and stretches almost to the top, with the reflection cutting right through to the base and beyond. Keeping the size of the main subject to a minimum creates large open spaces; this, along with the effect of a fading evening light, should give the viewer a real sense of peace and tranquillity.

Items you will need for this exercise

Warning:
Please read and digest all the instructions at each stage before proceeding with the painting.

- **Watercolour paper, 300gsm (140lb)**
- **Brushes**
 - ... 2.5cm (1in) hake
 - ... 6.5mm (¼in) flat brush
 - ... Two round paint brushes, size 2 and size 5
- **Watercolour paint**
 - ... Light red
 - ... Payne's gray
- **Water bowl**
- **Mixing tray**
- **Cloth/rag**
- **Drawing board**
- **Masking tape**
- **Kitchen paper**
- **Pencil**
- **Fine-liner pen**
- **Small ruler**
- **Hair dryer**

Panels and planning

There are seven main panels in this picture, plus the reflections and final details. The whole background wash is the first, followed by the two headlands. The hull of the boat consists of two panels, and the sail also has two.

Once you have drawn the boat and the position of the headlands, the whole wash becomes the first section to paint. When that is dry you can paint the two headlands, letting them dry in between and then painting in the remaining panels of the boat. This is actually a very straightforward plan with little to think about.

Making a preliminary sketch

The pencil sketch will help you understand the tonal value of the various parts of the picture. It will also give you a little practice at drawing the panels of the boat. When sketching, you need to avoid over-erasing any mistakes on the watercolour paper, as it can wear down a patch that might be visible through the paint afterwards.

The exercise

Stage 1: Initial drawing

1 Take a piece of A5 (148 x 210mm or 5¾ x 8¼in) size watercolour paper, portrait format, and tape it to the board all the way around. Set the position of the boat so that the bottom of the hull is just above centre left. Next, carefully draw the two panels of the hull and the sail as pictured. You could argue that the hull has three panels because you can just see inside it. As you will see later though, you will only paint two sections. Sketch the headlands about a third of the way down the paper. The sailor is just the thick end of an upturned parsnip and a dot, just like the people in the previous exercise (see page 57). Avoid adding too much detail.

TIP

Feel free to produce a larger version if you like, but bear in mind you are advised to use a larger hake for the wash if you do.

Stage 2: Painting the wash

2 Squeeze a generous blob of Payne's gray and a smaller blob of light red onto the palette. Soak the 2.5cm (1in) hake and wash clear water across the whole paper. It needs to be evenly wet and no water running on the page. Pick up a little light red on the tip of the hake and sweep it across from top to bottom. Keep sweeping up and down in horizontal bands until the light red paint is evenly distributed. Make sure the hake passes all the way across the masking tape so that there aren't any weaker-coloured patches at the edges of the wash. Add more red if it looks a bit pale, but be quick! **Do not wash the brush**.

3 Go straight to the Payne's gray and pick up a small amount on the tip of the hake. Sweep the colour across the bottom of the picture and gradually move upwards in horizontal bands, all the way to the top. The Payne's gray should weaken as it empties out of the brush, giving a graduation of tone from bottom to top. Pick up more Payne's gray and keep repeating this process, taking the hake off the paper just before you reach the top. Leave it progressively further from the top each time you sweep upwards. This whole wash should be performed very quickly so that the water can even out any irregularities when you have finished with the brush. You will need to make four or five passages, depending on the amount of paint used. In the picture the hake is just starting its third passage upwards.

4 As soon as you have finished with the hake, take the size 5 brush and pick up a **small** amount of Payne's gray on the tip of the brush. Gently sweep a few lines across the paper, from left to right, to represent ripples in the water. This must be done while the paint is still damp, so that the lines soften at the edges and blend into the wash. You can see the shine in the wash indicating how wet the paper still is at this point. Use some kitchen paper and mop any excess water from around the edge, then dry thoroughly with the hair dryer. You will notice that the paint fades as it dries.

TIP

As you dry the wash with the hair dryer, look out for any pools of water that are standing in any dips in the paper. If there are any, get the hair dryer close and dry these first. This will prevent the water from creeping into the surrounding dry areas and forming watermarks.

Stage 3: Painting the headlands

5 Mix a little Payne's gray and light red together and test the mix on a scrap bit of paper to make sure you have the shade required for the nearest headland. Take some of this paint on your brush and put it to one side on the palette, then add some water to it – this will give you a weaker version of the same colour for the distant headland. Use a size 2 brush and swiftly paint the distant headland, moving from one side to the other. Remember: don't paint the ridge first, otherwise it will form a line along the top, and **don't go back and fiddle!** Dry this with a hair dryer before you paint the next headland to prevent them bleeding into each other.

6 Use a size 5 brush and paint the near headland with the stronger mix of paint, following the same method as before: paint in the feature from one end to the other, and resist the temptation to keep going over the same strokes.

Stage 4: Painting the boat

7 Using the weak mix of Payne's gray and light red from the previous stage, paint the entire hull of the boat as though it were one panel. Dry this with a hair dryer.

8 Then, using the stronger shade of Payne's gray, fill in the whole rear panel of the hull of the boat.

9 Using the size 2 brush, paint the upper panel of the sail with light red and then quickly run in a tiny bit of Payne's gray on the right to give it some shape. You may need to **wash and dab** the brush and gently blend the grey into the red while it is still wet. Dry this.

10 Follow the same process in Step 9 for the lower panel of the sail and blend the grey into the red, ensuring that you get a contrasting edge where the two sail panels meet.

11 Use the 6.5mm (¼in) flat brush to paint the reflections. Wet the brush first and pinch it so that the bristles flatten to form a sharp chisel shape. Pick up a little Payne's gray, and holding the brush with the flat edge horizontal to the paper, gently sweep it across and paint some zigzag lines as pictured. Make sure they are roughly the same width as the boat.

12 Now do exactly the same with light red and ease the brush down in zigzag patterns leaving complete breaks here and there. The sail tapers to a point so you will need to make sure that the reflection diminishes to a point towards the base.

13 Paint or draw some very fine lines on the side panel of the boat to represent the planks that these type of small vessels are often made from. Try to curve them slightly and leave them short of the bow.

Note: The reflection is longer than the sail.

Stage 5: Final details

When it comes to the final details in any painting the pressure is on. After all, you have completed each stage successfully and it may be those final touches that make or break the picture. Get it right – Hallelujah! Get it wrong – ruined! This is the same for any artist at any level so please don't worry, it's something we all have to go through. My advice is to predetermine what details you intend to include, then experiment on scrap paper and practice before committing to the painting.

A good example of this exists in this exercise. If you want to include some rigging for the mast, you must decide the best method to use. It may be that one method is more successful for you than another.

Your decision should be based upon what worked well for you when you experimented on scrap paper. Once you have made that decision, practise your brush or pen strokes several times before committing to the painting. It really is worth the effort and should help prevent any unwanted mistakes.

I used a black superfine fine-liner pen for all the final line details and a size 2 brush with the stronger shade of Payne's gray to paint in the figure.

YOU HAVE SEVERAL OPTIONS:

- Use a fine rigger and paint the lines freehand. This may result in a slightly curved line. You have to decide if that is desirable or not.
- Use a rigger or other fine brush and guide it along a ruler with the bevelled edge turned upwards; this allows you to run the shaft – or ferrule – of the brush along the ruler's straight edge and guide the tip of your brush to paint a straight line.
- Use a superfine fine-liner pen either freehand or with a ruler.

14 I used a bevelled ruler and a fine-liner pen to draw the mast and ran a freehand stroke with the pen to draw the rigging line. You can see it is a little broken in places which makes it look finer. Avoid a thick and solid black line, it won't look right. There is also a little knot in the rigging and a flag on the top.

15 Use the rigger and Payne's gray to paint a squiggly broken line to represent the reflection of the mast. Ensure it follows the same line as the mast otherwise it will look odd.

Your painting is now complete and I hope it was successful. If there is any part of it that you are not happy with, you will hopefully understand what went wrong and know what you could have done differently. This is all part of the learning process so don't be too despondent!

Taking it further

On the theme of boats reflecting on the water, here are two other exercises that you can try on small pieces of watercolour paper. I would encourage any artist to play with ideas and doodle with quick sketches. It helps develop technical skills and often sparks ideas for bigger paintings.

Using ultramarine blue and Payne's gray, roughly sketch the body of the boat and the mast. Wash clear water from the top to the horizon with a size 8 round brush, and then drift in a few horizontal lines of blue to represent clouds. When this is dry, add horizontal bands of blue below the horizon line for the sea, making sure you weaken the strength of the blue as you work down. When the sea is dry, lift the paint off the right side of the boat with a damp brush and kitchen paper, along with its reflection. You can then use a size 2 brush to paint in the details on the boat and the reflections. The darker areas are painted with Payne's gray to give the boat some contrast with a strong sense of light coming from the right.

Using cerulean blue and Payne's gray, draw the boats first – note that there is no horizon. Using a small hake, wet the paper from top to bottom, then gently ease a little cerulean blue wash throughout the whole picture. Pick up a little more on the brush and sweep it in at the top to leave a lighter band through the middle. Without washing the brush, pick up a little Payne's gray and run it upwards from the bottom up to as far as the boats. When this is dry, you can then use strong Payne's gray to paint all the details of the boats.

The hull of the central boat is paler on the sides because the light is at the back of the scene. To do this, you will need to paint right across all three panels of the hull with weak Payne's gray and then, when that is dry, complete the central panel – the stern – with very strong Payne's gray. You can see how the reflections replicate the details on the boat, but are upside down and fragmented. This is similar to 'Red Sail Reflections' on the page 66. Other than that, all the other panels are silhouettes and are painted with very strong Payne's gray. Use a 6.5mm (¼in) flat brush horizontally to produce zigzag-shaped reflections. Use the bevel on a ruler with a size 2 brush for the masts, and a rigger for the rigging lines.

This detail is taken from 'Tranquil Harbour'.
For the complete painting, turn to page 122.

TIP

If you have made mistakes in your final painting, they will most likely be irreparable because of the nature of watercolours. Do the whole painting again and, if necessary, repeat it several times. This may seem laborious but it is the best way to achieve perfection. Sometimes you have to be determined and persistent to get the best results. There are many occasions when I have repeated the same painting. The adoring public don't know this, and they only get to see the best one!

understanding colour & mixing

4

"Most artists will agree that it is better to use a limited palette and learn how to mix."

Which colours should I use?

There are dozens of colours to chose from in the ranges provided by manufacturers and they obviously want you to buy as many as possible. This really isn't necessary and most artists will agree that it is better to use a limited palette and learn how to mix. This will help the colours in your paintings to complement each other rather than clash, and will save you money at the same time. You will find your own favourites, depending on the subjects you choose and the development of your style.

The colours on my palette

Raw sienna
A light creamy shade which is plentiful in nature and very neutral. Perfect for skies, sand and stones.

Alizarin crimson
A red at the other end of the scale to light red, giving that 'red sky at night' colour.

Ultramarine blue
A strong blue in the middle of the range, with good granulation properties which easily mix.

Payne's gray
A dark charcoal pigment which is light and delicate diluted and almost black when strong.

Cerulean blue
A light blue with a touch of the Mediterranean about it. Turns deep turquoise with a touch of lemon yellow.

Lemon yellow
A strong and bold yellow with the fluorescence of a highlighter pen. A perfect base for mixing greens.

Light red
Actually sits within the range of browns but gives a superbly rich terracotta-red shade.

Burnt umber
A brown with plenty of intensity, beige when diluted and rich dark chocolate when strong.

You will notice that there is no green on my palette. This is because green is a very easy colour to mix and I can achieve a comprehensive range of green shades by combining some of the other colours – more on that shortly.

Mixing colours

I get asked often about colour mixing. It seems it is a challenge to most leisure artists. There is an element of trial and error, but if you accidentally reach your target shade you may not be able to replicate it again. There are some definite principles to work from and I will do my best to help you understand this.

If you pick a colour from a chart for your living room, it is unlikely to be available off the shelf. The DIY store will need to mix it for you. The code of the colour is entered into a computer and it then tells the operator which base shade is required. There are only a few base shades necessary. The injection of the other pigments into the base tin is what will ultimately provide the colour you require. This is exactly the same on a watercolour palette. It is very important to understand about base colours first.

Key idea to take away

- *Understanding primaries and base colours will help you mix the shade you require.*

Primary colours

A prime number is one which cannot be achieved by multiplying two different whole numbers together such as 7, 11, 13, etc. A similar principle is true of primary colours, in that they cannot be achieved by mixing two colours together. Unlike prime numbers, though, there are only three primary colours:

RED BLUE YELLOW

Generally speaking, most shades and colours are created by mixing the primaries together. For example, yellow and blue for green; blue and red for purple; yellow and red for orange; and all three for brown. When you are trying to create a particular colour, it is really important that you know where to start.

Base colours

When you want to create a particular colour, it is rarely a 50:50 mix. If you start with the colour which has a lower percentage content, you will use far too much of the other colour to achieve the required shade. Green is a perfect example of this: the ratio of yellow and blue to produce green is around 75:25, therefore the base colour is yellow. It really doesn't require much blue to turn yellow into green. If you start with blue, you will end up using half a tube of yellow before it turns green. Each shade you want to create will have a base colour, and it is important that you know what they are.

Colour strips

I recommend wholeheartedly that you play with colour mixing and produce colour strips which you can keep for future reference. Doing this exercise will also help you to understand base colours, what to add, how much to add and how much water to use. First of all, write a list of abbreviations for the colours you are using, as shown right.

Choose a colour or shade that you want to create and write that down as a heading. Then clearly record the base colour. Start on the left-hand side with a swatch of the base colour, and then start adding the other colours and create a swatch of the result each time. In between each swatch, record what you added with an abbreviation for the colour. This will give you a permanent record to keep and refer to if you ever need to find a particular colour for your painting.

You can create your own colour strips, of course, but here are some examples below.

Abbreviations

RS	Raw sienna
UB	Ultramarine blue
CB	Cerulean blue
LR	Light red
AC	Alizarin crimson
PG	Payne's gray
LY	Lemon yellow
BU	Burnt umber

GREENS

BASE COLOUR: LEMON YELLOW

+ RS, + UB, + UB, + UB, + UB

+ UB, + UB, + UB, + LR, + PG

In these two examples you can see how the colour trail changes. I added a little raw sienna to the yellow in the first line, whereas in the second line I added ultramarine blue immediately, and then light red and Payne's gray at the end.

TURQUOISE

BASE COLOUR: CERULEAN BLUE

+ LY, + LY, + LY, + LY, + LY

PURPLE

BASE COLOUR: ULTRAMARINE BLUE

+ LR + LR + LR + LR + LR + LR

+ AC + AC + AC + AC + AC + AC

You can see in the colour strips above that mixing either light red or alizarin crimson with the ultramarine blue takes the shade down two different paths. The light red produces a deep and hefty purple, whereas the alizarin crimson tends towards lilac and violet.

ORANGE AND BROWN

BASE COLOUR: LEMON YELLOW

+ LR + LR + LR + UB + PG

RED

BASE COLOUR: LIGHT RED

+ AC + AC + AC + UB + UB

In this strip I have shown how you can create a range of different red shades by combining light red and alizarin crimson. If you wanted the colour of a British pillar box for example, you might use either of the two in the centre.

Black and white

You may have observed an absence of black or white on my palette. They are manufactured but are seldom used by the watercolour artist, even though Ivory Black and Chinese White appear in most sets. If you require an exceptionally dark shade you can use black, but I find really strong Payne's gray to be dark enough for my needs. The pigments in Payne's gray separate when blending; this creates a much better effect and also works perfectly if you want to darken a shade slightly.

The absence of white, however, is more significant. It is impossible to highlight with Chinese white because it just won't sit over dark paint. What actually happens is that the water in the paint re-activates the dark pigments underneath and they mix with the white, leaving a horrible dirty grey colour which fades as it dries. The other solid paint mediums like oils and acrylics need white to mix paler shades and create highlights on top. This just doesn't work with watercolours because of the impermanence of watercolour pigments.

USING THE WHITE OF THE PAPER

Watercolour pigments are suspended in water which results in a translucent finish. The lower the density of the paint particles in the water, the more of the paper will show through. Therefore, a watercolour artist tends to use the paper to lighten colours, instead of white paint. It's quite simple really: to create paler shades, add more water.

The examples below show how alizarin crimson fades to a pale pink, and burnt umber fades to a beige, with just the addition of clear water.

Taking it further

To help you understand colour mixing and practise blending, try creating some colour spectrum swatches. Use plenty of water and a size 8 round brush. Prepare the colours on the palette and then drag them into each other to create a colour blend. Use horizontal brush strokes as if you were using a hake in the previous exercises. Watch the pigments separate, blend and granulate in front of your eyes. If you allow them to dry normally instead of using a hair dryer, you will observe how the moving water continues to change the blending after you have taken your brush away.

Light red, burnt umber and Payne's gray blended together

Raw sienna and Payne's gray

Alizarin crimson and ultramarine blue

Cerulean blue and Payne's gray

Lemon yellow, green (made by mixing lemon yellow and cerulean blue) and purple (made by mixing ultramarine blue and light red)

Left
You could also try converting a swatch into a mini painting such as this one, using raw sienna, lilac (mixed with ultramarine blue and alizarin crimson) and Payne's gray for the boat.

Below
Perhaps you could try an instant mini scene using raw sienna, burnt umber, light red and Payne's gray. Painted freehand in two minutes while the whole thing is wet and then allow all the colours to blend.

The final two paintings

5

"Every artist who has ever painted a picture will be aware of something that could have been better ... but anyone viewing your work will be oblivious to the things you don't like."

Exercise Six:
'Lake in the Snow'

This scene consists of very few panels but each one requires a completely different technique and degree of water control. Four large trees are reflecting in a lake which is surrounded by freshly fallen snow. The sky has a light area just right of the centre which reflects in the lake. The background trees, which are soft and hazy, are arranged with a space at the same point as the light area of the sky and thus creates a definite focal point, giving plenty of depth.

Items you will need for this exercise

! Warning: Please read and digest all the instructions at each stage before proceeding with the painting.

- **Watercolour paper, 300gsm (140lb)**
- **Brushes**
 - Two hakes, 2.5cm (1in) and 5cm (2in)
 - Rigger
 - Two round paint brushes, size 5 and size 8
 - 6.5mm (¼in) flat brush
 - Foliater brush, medium size
 - Cheap throwaway brush
- **Watercolour paint**
 - Light red
 - Payne's gray
 - Raw sienna
 - Ultramarine blue
- **Permanent white gouache or white acrylic paint**
- **Water bowl**
- **Mixing tray**
- **Cloth/rag**
- **Drawing board**
- **Masking tape**
- **Masking fluid**
- **Kitchen paper**
- **Pencil**
- **Kebab skewer**
- **Hair dryer**

Panels and planning

As you can see in the diagram to the right, there are ten main panels to paint. Once these are complete, collected snow can be added to some of the branches by laying gouache or acrylic paint on top, and I shall provide detail on how to do this later on in the exercise.

On page 75, I emphasised that you should leave the colour of the paper showing through to create a white shade; in this painting of a snow scene, this is exactly what I have done. In order to keep the darker paints off the snow area, it is necessary to have a good think beforehand about how that might be achieved.

In this particular case, the use of masking fluid is really the only option. Once that has been applied, the paint in the sky and the lake can be dragged right across the masking fluid, which prevents you from having to create the defined edges of the panels with a brush – something which would slow you down and undoubtedly create horrible lines and watermarks on the paper. The trees are also painted over a masked edge which makes them look as though they are growing just beyond the snow horizon. The masking fluid can then be removed to reveal pure white paper beneath, and the shadows in the snow painted using clear water with a little purple paint dropped in. A few final details then complete the painting.

Panel 1 – sky and background trees

Panels 3, 4, 5 and 6 – tree trunks

Panel 10 – snow

Panel 2 – lake

Panels 7, 8 and 9 – tree reflections

Making a preliminary sketch

An initial sketch will help you decide on the proportions and positioning of all the features in the picture.

The line of snow starts about a third of the way up on the left-hand side of the picture, and falls to less than a quarter of the way up as you work towards the right-hand side. The lake cuts in from the right and passes almost all the way across the snow, capturing the reflections of the three trees. The shape, width and angle of the trees will need some practice, and may be a case of trial and error, before you finally commit to painting them on paper.

Watercolour techniques

There are three new techniques used in this section, and I advise you to practise them first. The doodle opposite shows how foliage has been created with the Foliater brush and how white trunks have been scratched out of the paint. Try a few of these before committing to your painting.

Scratching

You will need a stick of some kind to perform a scratch. I like to use a kebab skewer because it is thick at one end and sharp at the other, enabling me to vary the width of the trunks and branches.

This diagram shows the action you will need to scratch the paint off the paper successfully. Hold the skewer away from you and press down while dragging it. The idea is to cut a slight groove in the paper which then removes the paint and leaves a white mark shaped like a tree trunk. The paint must be semi-dry before you can do this. If it is too wet, the paint will run into the groove. If it is completely dry, the paint won't scratch off at all. Stippling and scratching techniques are described in detail and accompanied by photographs in Stage 3 of the painting.

Stippling

Unlike soft watercolour brush strokes, stippling is an action that brings the paint down onto the paper in a series of delicate 'punches'. Achieving this requires much firmer bristles. The paint on the end of the bristles should leave a coarse, textured pattern that looks like foliage.

The Stephen Coates Foliater brush has been specially designed by me to do this job efficiently. The brush has a curved top, a flat underside and has been cut back to assist with the painting angle. The brush head has a delicate mix of Hog bristle and fine hair; this provides firmness for stippling and allows good water holding capability. Of course, you may like to use your own favourite hog hair or stencil brush to stipple.

Masking fluid

Masking fluid is available from many different manufacturers. It is normally a cream-coloured, thick liquid which is applied in the same way as paint, and is rubbery when dry. It is extremely useful for watercolour painting as you can paint over it and it will protect the paper. When the paint is dry, you can then rub or peel the masking fluid off to reveal the white paper underneath.

> **Warning:**
>
> Masking fluid sets very quickly and will coagulate in the bristles of the brush. Once the setting process has begun it will not come out of the bristles and the damage will be permanent. Just a few seconds will be enough to ruin a good paint brush, even if you wash it thoroughly. For the same reason, avoid using masking fluid while wearing your Sunday best!

I advise you to use an old or cheap throw-away brush to apply the masking fluid. The bottle will need just a gentle shake first. Apply the masking fluid and wash the brush out completely every ten seconds. This will prevent a build up of fluid in the bristles. If you leave it too long, the masking fluid will set on the brush and leave you with a lumpy mess which cannot be removed.

The exercise

Stage 1: Initial drawing

1. Take a piece of watercolour paper, approximately A4 (210 x 297mm or 8¼ x 11¾in) or up to 356 x 279mm (14 x 11in) in size, and tape it all the way round in portrait format. All you will need to draw are the lines for the horizon, lake and trees. To create the impression of naturally built-up sections of snow, let the horizon line fall gently to the right and sketch a few undulations in it. The back line of the lake should be straight and almost parallel to the top and bottom of the paper, as you don't want it to end up looking as though it is sloping. Sketch the angular outline of the trees, starting from the horizon line and up through the top of the picture. The left-hand edges of the trees are lighter and should be less defined; this is so that dark pencil lines are not visible after painting.

Stage 2: Masking the painting

2. The shaded area in this diagram shows where the masking fluid should be applied, which is the snow-covered ground. It needs to be about 2cm (¾in) wide and should be painted over the pencil lines so that they can be erased once the masking fluid has been removed. Remember: **wash the brush every 10 seconds during application.** Make sure the masking fluid is completely dry before moving on to the next step.

83

Stage 3: Creating the first wash

You will be under a fair amount of pressure when performing this first wash because there is a lot to do in very little time. Therefore, it is extremely important to prepare thoroughly in advance.

You have a maximum of two minutes to get all the sky in place and then a further two minutes to stipple. The point at which the scratching is done has to be timed carefully, which I shall cover shortly.

```
THE TIMELINE FOR THE WASH IS AS FOLLOWS:
1  Wet the paper with clear water.
2  Wash raw sienna across the whole sky.
3  Paint indigo across the sky to form clouds.
4  Stipple lightly to create hazy tree tops.
5  Keep stippling, getting darker towards the snow line.
6  Use a skewer to scratch out tree trunks.
```

PREPARING THE PALETTE

It will take you much longer to prepare the palette than it will to paint the wash. An unprepared palette will lead to delays which you cannot afford.

3 Squeeze out a generous blob of ultramarine blue, raw sienna, light red and Payne's gray, leaving a space between each of them.

4 Add water to the blue and create a thick, sludgy paste. Next, carefully add a little light red until you have mixed a strong indigo colour. Add the light red sparsely in stages. If you overdo the red, you will end up with completely the wrong colour. The raw sienna and Payne's gray are used straight from the tube and not diluted.

TIP

If you feel that you may need a little more guidance on how to work your wash, you can do a quick sketch of the intended sky and place it next to your paper (see the detail on the right). You can then refer to it as you introduce the sky colours. Anything that assists you in working decisively and quickly is a bonus.

CHECKLIST

Before you start your wash, check that everything is in place:

- Palette prepared
- Your brushes - the large hake and Foliater
- Kebab skewer
- Kitchen paper
- Hair dryer, plugged in

5 Thoroughly soak the 5cm (2in) hake. Wash clear water across the whole sky and over the masking fluid. Try to create an even film of water across the whole of the paper, making sure it is not running and there are no dry patches. Pick up some raw sienna and pull it across the sky. Try to get a bit more paint at the focal point. If the result is a little patchy, don't worry because it will probably help you to get a little tonal variation. **Do not wash the brush.**

6 Immediately pick up your mixed indigo and, using broad strokes to start with, pull the paint across the paper. Try to create a tapered shape by turning the hake slightly in your hand as you pull the paint brush towards you.

7 Pick up some more paint and brush across the top right-hand corner. Depending on how much paint there is in the brush, finish off by turning the hake sideways as you pull it across the paper to create a narrower stroke. If the brush is empty you may need to pick up a little more paint. All this must be done quickly and the paper must still be wet when you have finished with the hake. If you can see brush marks in the wash, don't try and smooth them off otherwise you will risk over-brushing. The water should still be moving on the paper and will naturally feather off the edges for you.

8. Put down the hake and immediately pick up the Foliater. Dampen the Foliater brush first with a little water, then pick up some mixed indigo and stipple the paper by very gently touching the bristles onto the wet sky. Repeat this delicate motion across the bottom of the sky, forming the tops of the distant trees. Vary the line and shape a bit and you should see the paint blend into the sky, leaving a soft and misty effect on the paper.

9. Pick up more indigo mix and gradually intensify the strength of the hue in the foliage as you work towards the horizon line. You can be aggressive with the brush now and punch down a lot harder on the paper. **Do not wash the brush.**

10. Drag out some Payne's gray on the palette with the brush and then stipple the lower part of the foliage to create a dark undergrowth. This should blend into the purple paint, which will produce a deep contrast with the tops of the trees. Make sure the Payne's gray covers the masking fluid line.

TIP

At this point you may have a small amount of water gathering along the top edge of the masking fluid line. This could potentially seep upwards into the rest of the wash and create a watermark. Dip the very tip of some kitchen paper into this small pool to soak up this excess water.

11 If the painting is tilted towards you as recommended, the top of the sky should now be drying nicely, but there will still be water on the horizon line where you have just stippled the background trees. You have to wait until the shine just starts to disappear before scratching out the paint. If you go too early, the water will run into the groove. Too late, and the paint won't scratch away at all. Press down hard and drag upwards, trying to vary the line of the stem.

12 Once you have scratched a few thick trunks, flip your skewer and use the sharp end to create thin branches for the trees. Mop up any excess water sitting on the horizon line, following the tip above. Now dry it thoroughly with a hair dryer.
You have now completed the wash – phew!

TIP
To speed up this drying process, switch the hair dryer to a low setting and have your skewer ready in your other hand. Watch the shine on the paint as you dry the paper, and as soon as it turns 'silky' like eggshell paint, strike with the skewer.

Stage 4: Painting the lake

13 This is only a small panel so there is no need to wet the paper first – simply dampen the smaller hake with clean water. Pick up some raw sienna and quickly swish it from side to side inside the outlined lake. Make sure you go over the edges and onto the dried masking fluid. **Do not wash the brush.**

14 Immediately dip the very tip of the hake into the indigo mix – make sure you do not to pick up too much – and gently paint a vertical stroke of the colour at the far left of the lake to create a reflection of the trees in the background. Repeat these strokes several times, moving slowly towards the centre of the lake. The indigo should gradually diminish in strength as you go, leaving raw sienna in the centre. If you don't think the purple is strong enough on the outer edge, pick up a little more and go over this section once more until you're happy. Repeat this process on the other side of the lake, this time moving from right to left. Providing the raw sienna is wet enough, the edges of the indigo mix should soften into it.

15 As you can see clearly above, the hake has passed all the way across the panel and onto the masking fluid. Start each stroke on the masked area, then pull the brush downwards, through the lake and onto the lower masked area. Remove any excess water with kitchen paper and dry the lake with a hair dryer.

TIP

If you accidentally over-extend the brush strokes onto the paper, quickly get a piece of kitchen paper and dab it off. Alternatively, it can be lifted out after the masking has been removed.

Stage 5: Painting the trees

The tree trunks are lighter on the left and very dark on the right. The dark paint must blend gradually across the centre of the trunks to create the impression that they are round. This process is exactly the same as the pebbles in Exercise Three (see pages 47–49), except here the subjects are long and thin as opposed to spherical.

You must ensure that the **whole** of the tree trunk is filled with very wet, light-coloured paint so that the dark paint will move and blend into it when applied. You will have already covered the lower part of the tree trunks with dark paint (your mixed indigo) when you stippled in the background trees.

16 Fill a size 8 round brush with water and gently scrub the paint with it on the tree until you see it lifting.

17 Dab the wet paint with a piece of scrunched up kitchen paper and the paint should lift out.

18 Keep repeating this on all the trunks until you have removed the paint. Don't get too obsessed about removing it all, as you want to leave the upper parts of the tree covered with the raw sienna intact.

TIP

Before painting the tree trunks in your main painting, have a practice first. Follow the steps on the following page and try painting a few, varying the amount of paint and water. Each one will be slightly different, as you can see on the right.

89

19 Create a large wet puddle of raw sienna on the palette and fill the entire trunk with it using a size 8 round brush. You will have to return to the palette with the brush several times to make sure the trunk is evenly wet from top to bottom. If any part of the trunk is dry, blending simply will not work.

20 Immediately pick up some Payne's gray on the tip of the brush and very quickly paint the right edge of the tree. Pick up more paint as you go up and complete the entire length. The Payne's gray should be strong but loose at the same time, otherwise it will not blend into the raw sienna.

21 Now **wash and dab** the brush and, with the very tip, quickly run it up the centre of the trunk with flicking strokes, making sure you catch the Payne's gray as you go. This will excite the water molecules at the intersection point of the two mixes and encourage the paint to blend.

One of the finished trees. It is really exciting, and thoroughly satisfying, when you watch the moving water carry the grey paint across and create the texture of the tree trunks. It's like a bit of magic!

22 You now need to capture the reflections on the trees in the lake below. This may seem obvious to some, but make sure the reflections are a true mirror image. If the tree leans to the right, the reflection will be upside down and to the right as well. Paint them using the same method as the trees in Steps 19 to 21 and – once again – make sure you paint over the masking fluid with each stroke.

90

Stage 6: Removing the mask

23 The paint must be thoroughly dry before removing the masking fluid, otherwise it will smudge and spoil the paper. Carefully rub the mask from one end and it should come away.

24 Once the mask has been removed you can then erase any visible pencil lines.

TIP
If you put the **masking fluid** on thickly enough, the whole lot should peel away in one go!

Troubleshooting
If any paint has leaked through the mask, you can clean it off by scrubbing with a damp brush and 'punching' the paper with some kitchen paper to lift it out. A 6.5mm (¼in) flat brush is ideal for this because the bristles are a bit shorter, and the flat profile helps you to get really sharp and clean edges.

91

Stage 7: Painting the snow

Snow is never actually white. It normally takes on the faint hue of the surrounding light. On a dull, cloudy day it will be grey, whereas on a bright sunny day the snow will have a blue tinge to it. In this picture the dominant colour is the indigo mix. The snow lies softly on the ground and has slight undulations where delicate shaded parts are evident. These areas do not have hard edges so it is necessary to wet the paper with clean water and drift a little purple in to create soft blended edges.

I recommend using clean water and brushes for painting the snow.

23 Prepare a little weak indigo on the palette and test it on a scrap of paper to make sure it is not too dark. Have a size 8 round brush ready. Use a 2.5cm (1in) hake to drift some clear water into the whole of the snowy ground around the lake. It is important that you cover the entire area evenly without any dry patches.

24 Without delay, pick up a little of the weak indigo with the size 8 round brush and sweep it gently into the wet area. Apply the indigo mix at three or four spots and vary the shape and intensity of each one if you can. If the indigo moves too much and bleeds down the paper, **wash and dab** the brush and sweep it across to get control of the flow. **Move quickly, as this all has to be done while the snow is wet**.

25 Now, with a size 5 round brush, pick up some indigo and quickly run a line across the back edge of the lake.

26 Immediately after this, clean your brush and run it along the lake edge again, this time a little higher than your previously painted line. Keep doing this until the indigo catches the water on the snow and forms a soft blend. You may need to **wash and dab** then sweep across it one last time to smooth it off. This should create the impression of snow gently declining as it reaches the water's edge. Dry the paper with a hair dryer to stop any watermarks forming at the edges.

Stage 8: Final details

27 Use a size 5 round brush and fairly loose Payne's gray to paint some branches coming off the tree trunks. Try to vary the direction they grow, and let them taper off to a fine, twiggy end.

28 Use a rigger to lightly paint in the fine twigs on the ends of the branches. You will notice that most of these fine twigs pass all the way out of the frame.

29 As we touched upon earlier, watercolour paint is not suitable for highlights because, when it is diluted by water, it becomes too thin and translucent. You will need to use permanent white gouache or white acrylic for this purpose. Grab either your white permanent gouache or acrylic paint and add just one drop of water to the paint to loosen it slightly. Load the brush, hold it down at a very low angle and scrape the side of the brush gently up the tree trunk. The paint should catch only the high parts of the textured paper and look like wind blown snow gathered on the rough bark of the trunk.

30 Add a little snow to the branches here and there and finish off with some birds to add a little life and movement to the scene.
You have now finished the painting, and I hope it went well.

The finished painting.

Taking it further

This painting is a variation on the previous exercise. The order of play and the techniques used are the same, but with the addition of cottages and a remote post box.

This study requires only raw sienna and Payne's gray for the sky, trees and snow. I used alizarin crimson for the letter box. The roofs of the cottages are protected with masking fluid. The falling snow is created by flicking white gouache on with a toothbrush, using the same technique as in Exercise 3 (see page 46). The smoke rising from the chimney is created by gently dabbing with a damp brush and touching with kitchen paper to remove the paint.

Exercise Seven:
'Peak District Walk'

Living on the threshold of the Peak District in the UK, I have immediate access to a great deal of magnificent scenery – in particular, the dark and white peaks of millstone grit and limestone which cut through the rising Pennine hills provide a true paradise for artists. Unfortunately, the British climate dictates that I frequently have to settle for painting from photographs rather than relaxing in the countryside with my art box, easel and picnic hamper – one drop of rain and it's goodnight, Vienna!

The challenge with photographs is that they often contain details which are both unnecessary and difficult to paint. It is normally a mistake to include everything you see in the image. Also, a lovely photo of your favourite place may not necessarily make a good painting. It is a case of understanding what to leave out, what to put in, and how to reduce your scope in order to produce a strong composition.

Items you will need for this exercise

- **Watercolour paper, 300gsm (140lb)**
- **Brushes**
 - 5cm (2in) hake
 - Rigger
 - Three round paint brushes, sizes 2, 5 and 8
 - 6.5mm (¼in) flat brush
 - Foliater brush, small size
 - Cheap throwaway brush
- **Watercolour paint**
 - Raw sienna
 - Alizarin crimson
 - Ultramarine blue
 - Burnt umber
- **Water bowl**
- **Mixing tray**
- **Cloth/rag**
- **Drawing board**
- **Masking tape**
- **Kitchen paper**
- **Pencil**
- **Kebab skewer**
- **Hair dryer**

! Warning:
Please read and digest all the instructions at each stage before proceeding with the painting.

From photograph to painting

The subject of this exercise is inspired by the photograph I took of the Longshaw Estate (see below), just south-west of Sheffield, UK. The rock structure in the painting actually exists, but the track and distant features (while typical of those in the area) are not aligned in real life as I have painted. After a series of sketches, I decided to rearrange some of elements in the scene, so that this composition would satisfy all the attributes I was looking for.

Above The original photograph
Right My final sketch, deciding the composition of the painting

The path has been deliberately widened to create a triangle which pulls the eye towards the focal point; it also reduces the area of heather and grass, which is tricky to paint and can over dominate. In addition, a hedgerow has been included to balance the composition. If you look closely at the finished painting on page 109, you can hopefully identify the implementation of my rules of composition found below:

MY RULES OF COMPOSITION

Alignment: The horizon, focal point or main subject should be off centre, both horizontally and vertically.

Balance: The weight of dark and heavy tones should balance horizontally across the picture.

Shape: Focal points are enhanced by deliberate use of curves, triangles and tapering lines incorporated into the features, including the movement and shape of clouds.

Depth: To create an illusion of depth, paint brave and bold foreground textures and hold back on detail and tone on distant objects.

Colour: Blend colours across the whole scene and avoid clashes. As I stressed earlier, use as few tubes of paint as possible and mix tones from a limited palette.

Panels and planning

Once again, making a plan before you paint is really important. Once the initial drawing is done, the order of play must be determined and the panels clearly identified.

Panel 1 – sky

Panel 3, 4 and 5 – distant hills

Panel 14 – hedgerow

Panel 6, 7, 8, 9, 10 and 11 – rock features

Panel 2 – path

Panel 12 and 13 – areas of vegetation

Preparing the palette

The sky contains raw sienna, alizarin crimson and ultramarine blue. A wash of raw sienna is laid down first, and then the clouds are built up by using a little of the crimson and then a deep violet colour, made by mixing together the ultramarine blue and alizarin crimson.

Prepare these colours as follows: squeeze out one generous blob (at least pea size) of ultramarine blue and a smaller blob of alizarin crimson. Using the size 8 round brush, add water to the blue and mix until you get a sludge-like puddle. Add a little bit of alizarin crimson to it and mix until you get a deep, rich, violet colour. Now add water to the alizarin crimson and create a puddle with a similar consistency to the blue, and add a little of the violet to it to ease off the redness. Have a generous blob of raw sienna ready also, but don't add any water to it.

The exercise

Stage 1: Initial drawing

1. Take a piece of watercolour paper, approximately A4 (210 x 297mm or 8¼ x 11¾in) or up to 356 x 279mm (14 x 11in) in size, and tape it to the board all the way round in landscape format. Sketch the features in the scene, using the final painting on page 109 as a reference and taking care to keep the upper parts light to prevent heavy lines showing through the paint afterwards.

Stage 2: Painting the sky

2. Soak your hake in the water, and bear in mind that it should remain chisel shaped throughout the whole wash. Wet the whole sky with water, sweeping the hake from side to side and using only the very tip of the brush with a fine feathery action. Keep adding water until the paper has an even film on it. **Once you have started painting, do not return the brush to the water at any point**.

3. Pick up a good quantity of raw sienna, ensuring it is evenly distributed across the tip of the bristles. **You now have a maximum of two minutes to complete the sky**. Sweep the hake across the whole sky, making sure that the raw sienna covers the entire area above the horizon line.

4. Now pick up a little of the alizarin crimson wash on the tip of the brush, turning it edgeways to create narrower lines, and pull it across the sky with a light flicking action. Try and create curves to enhance the focal point at the centre right of the painting. **Don't wash the brush**.

5. Pick up some violet and, using the same action in Step 4, pull the colour into the sky from the edges of the paper. If you turn the hake during the stroke, it will create tapered clouds. The water on the paper should soften the edges of the brush strokes. If there is insufficient water, the edges of the clouds will be hard and the brush strokes will be streaky. **Once it has started to dry do not, under any circumstances, go back to make improvements**. It will streak and you will ruin it, I promise! Now give it a thorough dry with the hair dryer.

The completed sky.

Stage 3: Painting the pathway

The idea is to lay down a base texture for the path with a horizontal movement. More details can be added later on as required. The paper below the horizon line does not need to be pre-wetted, because the path is a much smaller area.

6 With a semi-wet hake pick up some raw sienna, turn it edgeways and brush narrow lines across the paper, passing over the sketched edges.

7 Using the size 8 round brush pick up a little violet and 'swish' the brush across, creating blended lines to represent depressions and textures in the ground. The raw sienna must still be wet to allow the edges of the lines to blend into it. A **wash and dab** and additional swishes may be necessary to get control of the violet if it bleeds too far into the raw sienna. Dry this.

Stage 4: Distant features

The three landscape features in the background become progressively more defined the nearer they are to you. Put a little violet to one side on your palette and water it down until it is very weak. Check it on a spare scrap of paper; it should be barely visible, as you can see in Step 8 below.

8 Fill the size 8 round brush with the weak violet and slowly ease the paint across, overlapping the rock feature and distant escarpment. It should be barely visible. Don't keep going over it and resist fiddling! Dry this.

9 The central feature is a rocky escarpment. Prepare some violet that is stronger that you used for the previous distant hill. The mix must be fluid. Fill the whole panel with this colour using a size 8 round brush. When this is done, change to the size 5 round brush, pick up a little of this stronger violet on the tip and dab it along the ridge to emulate a distant rocky edge. The paint should bleed a little into the weaker violet.

10 **Wash and dab** the brush. Gently touch the stronger violet on the ridge with the tip of your brush and pull down the paint with short feathery brush strokes. Again, don't overdo it – the clock is ticking! Dry this with the hair dryer.

11 The nearest rock feature on the right should be filled with some weak raw sienna. Sweep a little violet into it to create texture.

12 Immediately repeat the same technique in Step 10 for the raw sienna rock feature, using the strong violet to create a ridge. Try to get this ridge a bit bigger and darker than the other one to create a sense of perspective. Also repeat the pull down technique to create some lines which follow the natural movement of the land. Dry this with the hair dryer.

Stage 5: Heather and moorland grass

It is virtually impossible to paint individual tufts or blades of grass with thick watercolour paint, especially with areas as large as this. This idea is to stipple very wet colours on separately, but deliberately allow them to touch each other so that they bleed and form little 'fingers' of vegetation.

You will need a pale highlight colour, a mid tone shade and a darker tone, the latter of which representing the areas of vegetation at the base of the tufts where there is much less light. These three colours **must** contrast with each other to a large degree in order to achieve a maximum effect.

The **two-minute rule** is the biggest challenge with this procedure. The areas of vegetation are quite large and it is necessary to use a relatively small brush to get the tufty texture. It is impossible to cover the whole area with the highlight colour and then progressively add the darker tones to bleed into it – you won't have time, and the highlight colour will be too dry by the time you add the darkest paint.

The diagram above left shows the whole area of the vegetation on the right-hand side of the path. Getting the highlights onto the whole area first will take too long, and it will be dry before you can add the darker tones to bleed into it.

The solution to this problem is to **divide the vegetation into a number of areas or 'bands'**, as you can see in the diagram above-right. For this painting, I have indicated three areas. You cannot draw these lines, otherwise you will see them through the paint, so you will have to use your imagination here or keep this diagram beside you as you work. The idea is to use all three tones in band 1 first until the moving paint is creating bleeds and mixes that look like vegetation. Once the area has been completed to your satisfaction, you leave the mixes to find their own way, then wash the brush and start on band 2.

THE THREE GRASS COLOURS YOU NEED ARE BELOW:

1. **Highlight – Light olive green:** Create this by mixing a small amount of ultramarine blue into raw sienna. You will need a large quantity of this and it needs to be very wet. This is the wettest of the three mixes because it is the first on the dry paper, and is the base for the other tones to bleed into. You will need a large puddle on your palette, enough to complete the whole band.

2. **Mid tone – Crimson:** Add a little ultramarine blue to alizarin crimson. This will give you the colour of heather in flower. Create a large puddle of this, not quite as loose as the raw sienna.

3. **Dark tone – Burnt umber:** This will provide all the dark areas within the vegetation. It will need to bleed into the other colours, so it has to be fluid. However, it also needs to be strong to create enough contrast. This is the driest of the three colours.

The first job in band 2 is to run some highlight colour along the top edge and 'catch' the darker-toned paint at the base of band 1. Some of the dark paint will bleed down and immediately create fingers or tufts before your eyes. Add the remaining tones to band 2, wash the brush, pick up the highlight colour and move on to band 3. Band 1 will now be drying so under no circumstances should you return to it.

What you are actually doing is gradually painting a single panel from top to bottom, adding paint and water as you go. In effect, you are splitting the panel up into several areas with each one requiring a two minute time limit, thus increasing the time you have available to paint the whole area.

Test all three colours on a scrap piece of watercolour paper first. Using a size 5 round brush, drop a short line of raw sienna onto the scrap of paper. Immediately pick up some alizarin crimson and dapple it into the raw sienna, then pick up some burnt umber and touch that in here and there. **Do not wash the brush between colours.** You should see the three different colours mix and blend; if you have the water quantities right, they should creep into each other and form moving fingers and tufts. You may need to change the consistency of the paint if the blending doesn't occur. Keep practising until you can see the mixes working and you have developed a feel for what is required in terms of consistency and mix.

TIP

All of this may seem a bit complicated. It is the natural behaviour of water that dictates these rules, so please don't be too hard on yourself if something goes wrong! If necessary, read through these instructions again to make sure you understand the principles of the procedure before moving on to the steps.

I advise that you use a size 5 round brush to start with, and then progress to a size 8 round brush as you work towards the bottom band. This should result in bigger tufts in the foreground, which will help to give a sense of perspective.

13 You will need to start at the horizon with the highlight colour, the light olive green; you will then touch in crimson and burnt umber successively. Wash the brush and start again with the highlight colour and work down in bands, as described on the previous pages.

14 Once you have completed band 1 it can be left to dry while you get on with band 2. Make sure you pull the colours in this area slightly into the next band before it is too dry. When you do this, try applying your strokes randomly to create tufts rather than stripes. A few white spaces also help to give the overall area of foliage some extra highlights. Use a size 5 round brush to start and then switch to the size 8 as you work your way down, increasing the width of the bands and size of the tufts. As you approach the path, use the burnt umber to paint sharp, tapered edges. When you have completed the whole area, you can either leave it to continue bleeding, or dry it immediately with a hair dryer if you are happy with the way the mixes have blended together.

15 Repeat the whole process on the left-hand side of the path. This time you will be painting the vegetation around the rocks. Apply the paint at the base of the rocks first, then move upwards so it is as though the vegetation is growing up in front of them. You can see that the rocks are unpainted at this stage but, for reasons I shall explain on the next page, this is the correct thing to do. Make sure the whole section is dry before moving on.

Stage 6: Painting the rocks

16 You will no doubt have some paint on the rocks from the sky, distant hills and the vegetation. You may need to lift off some of the paint, especially in the parts which will be lighter in colour. Scrub gently with a damp brush and lightly lift the paint by dabbing the wet area with kitchen paper.

PREPARING YOUR PALETTE

Your palette may well have dried up as you were painting the grass and heather, so you will need to spend some time getting it ready for the rocks. You will need some raw sienna, some of the violet and the burnt umber, all of which need to be fluid. The burnt umber, as before, should be quite strong. To loosen the drying paint, simply add a little water to the colours.

17 Paint each section of rock separately and dry in between. Use a size 5 round brush and fill with loose raw sienna. Without washing the brush, quickly sweep in a little violet and burnt umber to blend and create texture. **Don't wash the brush**.

18 Pick up some really strong burnt umber and finish off on the left-hand and under sides. The colours should blend and produce rounded-looking edges. **Wash and dab** the brush and sweep it across the intersection of the different tones to smooth them off. Dry before moving on.

19 Continue onto the middle section of the rocks and paint this in exactly the same way as before.

20 The lowest rocks are nestled in the grass. It isn't possible to paint light-coloured foliage over the dark colour of the rocks. As previously explained, watercolours have to be painted with the dark tones introduced at the end of the painting. What you need to do is make the grass look like it is growing up in front of the rocks, even though the grass has already been painted. This is another example of negative painting in the piece. You are actually painting the rock but you are also creating the impression of the tufty tops of the grass by cutting down into the paint that is already there. You can clearly see this in the photograph on the right.

21 Paint the remaining rocks in the same way as the others, but remember to use the strong burnt umber in the panel to cut down into the grass and heather which have already been painted.

22 When the rocks are dry, you can use a rigger and some burnt umber to paint narrow cracks and indentations in the rock face. You will note that they run all the way along the rock which makes the cracks look continuous. Avoid painting little 'sausages' by making the lines of paint as thin as possible.

Stage 7: Painting the hedgerow

23 Using your chosen stippling brush to create the foliage, gently punch a weak violet mix onto the ridge. Start with the upper parts then gradually work your way down. Remember to leave plenty of gaps to create the impression of light shining through the leaves.

24 Now quickly start to introduce stronger tones.

25 Steadily increase the depth of the paint as you work down towards the base of the hedgerow, and finish off with a very strong burnt umber.

26 Quickly pick up a size 2 round brush full of strong burnt umber and taper the hedgerow off towards the path. Spike down into the grass, to make it look as though it is standing up in front of the dark hedgerow. This is exactly the same technique as you used for the grass around the rocks. The whole hedgerow should still be wet.

27 When the paint is almost dry, use the thick end of a kebab skewer and scratch off a few of stems in an upwards direction. Use the thin end of the skewer for some fine twigs. This procedure is described in more detail in Exercise Six on page 87.

28 Once the hedgerow is completely dry, you can then use a size 2 round brush to paint the fence posts, and a rigger to paint the saplings and fence wire. Both are created using burnt umber.

Stage 8: Final details

29 Most of the final touches will be in or around the path. You can add white stones by gently scrubbing a small patch with a damp brush and then lift off with kitchen paper.

30 Wet the stones with clear water and blend a little burnt umber in on the lower section. To add a little depth to the undulations across the path, you can gently paint a few horizontal lines with either the violet or burnt umber, or both if you like!

31 You may need to enhance the sharp edges of the path. Do this with a little burnt umber, using a rigger or size 2 round brush – but take care not to overdo it. If you would like to include figures in your painting, walking and enjoying the scenery, all you need to do is create parsnip-like shapes with dots for the heads.

If you feel confident, add some birds to your painting using a rigger and some burnt umber. However, make sure you practise painting them on a scrap piece of paper first.

108

The finished painting.

Judgement day

It is highly unlikely that you will feel 100 per cent satisfied with a finished painting. Every artist who has ever painted a picture will be aware of something that could have been better, no matter how small or insignificant the detail might be. These minor judgements that you make will be yours and yours only. Anyone viewing your work will be oblivious to the bits you don't like! Take comfort in the fact that if you feel that way about your own completed work, you are a member of a very large club indeed.

Evaluation tips

- Finish

 Unless you have made an irreparable mistake early on, always finish a painting. It is my assertion that any work of art should not be evaluated until it is at least three-quarters complete. This is particularly relevant with watercolours because it is usually the darker tones added at the end that bring the painting to life.

- Wait

 From the outset, you will have had a very clear idea about what you were intending to create, especially if you were working from a photograph or copying another painting. It may be different from your intentions and therefore a little disappointing. However, this feeling of disappointment will fade as the brain clears away the intended image and your own finished piece sinks in. My advice is to look at your painting again the next day; you will be amazed at how differently you will view your work.

- Distance

 A wall-mounted painting is normally viewed from at least a metre away. Unfortunately, we are cursed with arms which are too short for us to be able to paint and evaluate at the same time. Keep stepping away during the process before making any decisions about alterations. Some details that are troubling you at an arm's-length will become irrelevant from a short distance or so. Always view your finished painting vertically, on a wall (if possible) and stand back.

Framing your painting

A watercolour painting will be messy around the edges and should always have a mount placed over it to remove the distraction. You will lose around 5mm (¼in) of the painting when you drop a cut mount onto it. If you can, have a mount the correct size ready and keep dropping it over the picture during the different stages of the painting. Any watercolour will look ten times better when mounted or better still, fully framed!

Conclusion & gallery

"The way you hold a brush, the movement of your hand, the choice of equipment, the colours and techniques used — all will lead to an individual style."

What to take away

In the introduction, I mentioned that the exercises in the book had been deliberately designed to be achievable by a beginner. However, you may have noticed that they became more challenging as you progressed through the course. If you struggled with any of the paintings, don't worry. Keep practising and try them again when you have further developed your technical skills with the paint. Above anything else, I hope you have started to understand how different watercolours are to other paints, and realised that you need to develop techniques and skills which are unique to the medium in order to progress as a watercolour artist.

Style

It is very unlikely that any of the paintings you have tried in this book will have turned out exactly like mine. This is nothing to worry about. No two paintings can ever be completely alike, especially in watercolours. The fluidity of the paint can create erratic results, meaning it is impossible to replicate any part of a painting accurately. After all, whoever heard of a watercolour forgery? The original could never be in question!

More importantly, though, as an individual you will have your own unique style, even if you are unaware of it yourself. The way you hold a brush, the movement of your hand, the choice of equipment, the colours and techniques used – all will lead to an individual style. If you try to copy another artist too closely, you are likely to be disappointed with the end result: first, the artist in question probably couldn't paint it for a second time – sometimes things happen with watercolours that just can't be repeated no matter how hard you try. Secondly, artists will have a unique set of movements or habits which will result in a particular style of their own. This is almost impossible to emulate.

Allow yourself the freedom to develop your own style. It is important to understand the medium you are using and develop technical expertise. How you then use it is your choice. Just let it flow!

The power of doodling

I have vivid memories of my childhood; in particular, when I pestered my poor father to draw things for me. As I remember, sky divers and the Daleks from *Doctor Who* were amongst my early favourites! My Dad was great at drawing and it fascinated me how he put things together with a series of shapes and lines. From as early as I can recall, I sketched and doodled with a pencil on any old bit of paper I could find. I became proficient as an artist from that tender age, not because I drew pictures, but because I doodled!

When you haven't got much time, or the idea of getting all your art stuff set up is too much to contemplate, I recommend wholeheartedly that you spend time with a pencil or a small paint brush and doodle. No matter your age or skill level, it is amazing how much your dexterity can develop by doing this. Producing lots of little sketches really does help create an 'auto-response' habit which sits deeply in the brain.

Most people find it difficult to draw something freehand. It is better to identify proportions and shapes before embarking on a drawing. Most natural or proficient artists are doing precisely that when they set out to draw something specific. Looking for representational shapes and lines becomes a habit to someone who is well-practised.

SKETCHING WITH A PENCIL

What follows are a few doodling or sketching exercises you can try to help develop your artistic talents. All you need is a pencil and paper.

PEOPLE

People are quite simply parsnips, with a dot for a head and then one or two other details added.

Start by sketching the basic shape and then develop the idea. You will be amazed at how quickly you can produce really good representations of human figures if you keep working at it. They only need to be a couple of centimetres (1in) tall, and don't just do a few - fill a page with them!

FREEHAND SHAPES

It is almost impossible to draw a circle freehand. For me, the easiest way is to draw a square and then gradually cut off the corners bit by bit. Try this with a pencil; you will be surprised how much easier it is to draw difficult shapes if you draw boxes first.

1 **2** **3**

Anything symmetrical is a nightmare to draw accurately. I recommend that you draw a box first, mark it with a centre line and then cut off the corners in a similar way to the circle above. In this example you can quickly develop an idea and then produce a small, completed sketch.

1 **2** **3**

The final shape, creating the bow of a boat.

SKETCHING WITH A BRUSH

Sketching doesn't just mean using a pencil. I would advise any watercolour artist to produce miniature practice sketches or doodles using a paint brush. Smaller paintings have smaller panels which are easier to complete within two minutes. Don't be tempted to use tiny brushes though as they will slow you down. Try to use as large a brush as you can manage for each panel.

It is also great fun painting these miniature sketches in a vignette style. Vignettes have no definite borders and, as such, they really help you to develop a sense of freestyle painting.

In the following examples, I used a size 8 round brush for a sky wash and other larger areas. I used a size 2 round brush only for the small details. These miniature practice sketches were painted approximately the same size as they appear on the pages.

A simple seaside sketch in raw sienna and ultramarine blue.

A lake scene using raw sienna, and purple mixed with ultramarine blue and alizarin crimson. The reflections of the hills were painted before the hills themselves while the lake was still wet. Then, I used masking tape to create the perfect straight edge along the horizon of the lake.

A grass field with some trees and a fence painted with greens, mixed using lemon yellow and ultramarine blue. The small details were painted with Payne's gray.

A rocky outcrop on the moors using raw sienna and ultramarine blue for the sky, raw sienna and burnt umber for the bracken, and raw sienna and Payne's gray for the rocks.

An instant doodle using raw sienna and purple, mixed from ultramarine blue, alizarin crimson and burnt umber. The sky is painted first then dried. The trees were stippled and the branches, gate and birds then completed with a rigger.

Final words

Watercolour is a difficult medium. Many things you try will not work out. You may paint a picture perfectly well but for some reason it just doesn't look right. Perhaps the colours clash, the composition is unbalanced or it lacks depth. It happens to me all the time.

On the other hand, you may have a brilliant composition but struggled on the technical side, making mistakes with the application of the paint.

Either way, don't give up. It is all part of learning and the development of your artistic skills. I have yet to meet an artist, professional or amateur, who creates a masterpiece every time. It doesn't work like that at all.

Do not be afraid of failure. It is an essential part of being an artist!

My message to you is simple. Be determined, be persistent and above all,

Practise, Practise, Practise.

One final thought before I finish: don't be afraid to let other people be the judges. There are billions of people in the world so, even if you are unsure about your own work, someone somewhere will love it!

Stephen Coates

www.coatesart.co.uk

Gallery

'Winter Walk'

'Path to the Forest'

'Tranquil Harbour'

'Padley Panorama'

'Dartmouth Bound'

'North Sea Cobbles'

'Burbage Brook'

'Bakewell through the Willow'

'Pennine Marsh'

'Light Explosion'

'Autumn Wood'

Index

Acrylic(s) 10–11, 15, 24–25, 30, 75, 93

Background(s) 15, 42, 59–60, 79, 100–101
Bands *see also* **Panels** 53, 61–62, 67–68, 102–104
Birds 15, 17, 57, 93, 108, 118
Bleed(ing) 57, 63, 92, 100–104
Blend(ing) 17–19, 20, 23, 25, 33–38, 41–42, 52, 62, 75–76, 89, 97, 103
- Controlling the blend 17–20, 34, 100

Boat(s) 59–68, 76, 116
Brush(es) 19, 24, 41–42, 49, 57, 80–82, 85, 102, 115, 117
- Flat 59, 68, 79, 91, 96
- Foliater 24, 79, 82, 96
- Hake 24, 39, 41–43, 51, 59, 68, 76, 79, 96
- Round 24, 30, 33, 39, 41, 51, 59, 67–68, 76, 79, 96
- Rigger 39, 41, 49, 57, 65, 68, 79, 96, 108, 118

Brush techniques 12, 15, 18–19, 30–38, 43–45, 49, 56, 65, 88, 93, 114
- Flicking 18, 19, 43, 55, 90, 99
- Loading 30–32, 35–37, 44, 47, 49, 53, 55, 61, 85, 89, 93, 99, 101, 105
- Neutralising *see also* Technqiues: Wash and dab 19, 35, 48, 55
- Pulling 34, 53, 85, 88, 99, 101, 104
- Punching *see* Stippling
- Scrubbing 23, 47, 50, 89, 91, 95, 105, 108
- Stippling 24, 81, 82, 84, 86, 102–104, 107, 118
- Sweeping 15, 18–19, 31, 35–38, 42–45, 48, 53, 61–62, 64, 68, 92, 99, 101, 105
- Tapering 42–43, 85, 99–100, 104

Clouds 15, 43, 52–54, 67, 84, 97–99
Colour(s) 10, 69–76
- Primary 72
- Base 72–74,
- Swatch(es) 73–76
- Themes 25

Composition 6, 33, 40, 51, 57, 59, 96–97, 119
Control(ling) paint 17–18, 20, 35, 92
Control(ling) water 12, 14–16, 18, 26, 34, 35, 79

Doodle 24, 67, 81, 115–117
Draw(ing), sketching 16, 34, 38, 40, 44, 47, 52–53, 60–61, 64, 67, 68, 80, 83, 84, 97, 98–99, 102, 115
- Freehand 52, 65, 115–116

Drawing board 26, 31, 33, 34, 39, 49, 51, 59, 79, 96

Effects, special 10
- Feathery / feathering 35, 42, 85
- Highlight *see also* Gouache 25, 75, 93, 102–104
- Illusion 16, 49, 97
- Soft blend 15, 35, 45, 48, 52, 54–55, 62, 88, 92, 99–100

Fence 15, 17, 107, 118
Figures 57, 61, 65, 108, 115
Fine-liner pen, superfine 59, 65
Focal point 15, 79, 85, 97, 99
Foliage 24, 42, 82, 86, 98, 102–107
- Grass 42, 97, 102–107, 118
- Heather 97, 102–107
- Hedgerow 97–98, 107
- Tree(s) 15, 17, 79–95, 107, 118

Framing 110

Gouache 25, 50, 79–80, 93, 95

Hair dryer 27, 39, 41, 45–46, 51, 55, 59, 62, 76, 79, 85, 87, 96
Headland(s) 52, 53, 56–57, 59–61, 63
Hill(s) 96, 98, 101, 105, 117
Horizon 52–54, 59, 67–68, 80, 83, 86–88, 97, 99–100, 104, 117

House 16, 18, 95

Kitchen paper 19, 27, 33, 35, 37, 39, 40, 45, 47, 50, 51, 59, 67, 79, 85–86, 88, 91, 95–96

Layer(ing) 30, 46
Light 15, 38, 50, 59, 67–68, 79, 92, 102, 107

Manufacturers 23–25, 71
Masking fluid *see* Techniques
Masking tape *see* Techniques
Mix(ing) 11, 17–18, 25, 31–32, 39, 69–76, 84, 97–98, 103, 117–118

Negative painting 39, 53, 106

Oil(s) 10–11, 24, 30, 75

Palette 24–26, 30, 34, 37, 41, 48–49, 52, 56, 71–72, 75–76, 84–85, 97–98, 101, 103, 105
Panel(s) 14–19, 24–25, 27, 34–37, 40–42, 47, 49, 52–53, 60–61, 63–64, 68, 79–80, 88, 98, 101, 103, 106, 117
Paper 11–14, 17, 20, 23, 27, 30–33, 36, 39–44, 47, 51, 55, 59–60, 62, 79, 93, 96
Path 97–98, 100, 102, 108
Pebbles, stones 71, 89, 108,
Perspective 53, 101, 103
Photographs, painting from 96–97
Pigment(s) 11, 24, 25, 39, 71–72, 75–76
Planning 14, 40, 48, 52, 60, 80, 84, 98, 105
Properties of paint 39, 71
- Binder(s) 11
- Particles 11–14, 17–18, 20, 24, 36, 39, 47, 75
- Suspended/suspension 11, 13, 39, 47, 75

Properties of water 12
- Bond(s) 11, 12
- Carrier 11–13, 90
- Evaporate(d)/ evaporation 12–14, 20
- Molecules 11–3, 90

Reflection(s) 80, 88, 90, 117
Rock(s) 97–98, 101, 104–107, 118
Ruler 39, 46, 51, 59, 65, 68

Sand 52, 71
Sea 53– 55, 67
Shadows 40–41, 44, 47, 49–50, 52
Sky /skies 15–16, 20, 25, 42, 52–54, 71, 79–80, 84–87, 95, 98–99, 105, 117–118

Techniques
- Lift(ing) out 25, 35, 37, 40, 47, 67, 89, 91, 95, 105, 108
- Masking fluid 23, 50, 80, 82–83, 91, 95
- Masking tape 27, 45, 54–55, 61, 117
- Scratching out 81, 84, 87, 107
- Toothbrush, using the 41, 46, 50, 95
- Wash and dab 19, 26, 35–38, 48, 55, 64, 90, 92, 100–101, 105
- Wet on dry 17–18, 32, 57, 63–65, 88, 90, 93, 101, 107
- Wet on wet 17–19, 32, 34–38, 45, 48–49, 54–55, 62, 68, 85, 86, 89–90, 92, 99–108, 117,
- White of the paper *see also* Masking fluid 47, 50, 55, 75, 80–82, 91

Test(ing) 40, 46, 49, 54, 56–57, 63, 65, 92, 101, 103, 108
Texture(s) 10, 15, 20, 23, 24, 36, 45, 71, 82, 90, 93, 97, 100–102, 105
Time/timing 12, 20, 23, 34, 36 40, 42, 44–45, 52–57, 61–62, 84–85, 90, 92, 102–103, 107
- Two-minute rule 20, 34, 42, 52–54, 76, 84, 99, 102–103

Tone(s) 17, 39, 52, 60, 62, 85, 97, 102–103, 105–107, 110
Troubleshooting 37, 91, 110
- Dry brush 19–20, 37, 38, 40, 42, 48–49, 55–56
- Hard lines/edges 37, 52, 92, 99
- Patchy 15, 35, 40, 45, 61, 85, 92
- Streaky 15, 20, 49, 99
- Watermarks 13–15, 26–27, 41, 56–57, 62, 80, 86, 92

Wash 27, 40–44, 53–54, 59–62, 67–68, 84–87, 98–99, 117
Watercolour paint 24
- Tube 10, 24–25, 35, 72, 84, 97
- Pan 10, 24–25

128

'Remote Posting'